LITTLE DANCER AGED FOURTEEN

ALSO BY CAMILLE LAURENS

Who You Think I Am

In His Arms

LITTLE DANCER AGED FOURTEEN

The True Story Behind
Degas's Masterpiece

CAMILLE LAURENS

TRANSLATED FROM THE FRENCH BY

Willard Wood

OTHER PRESS NEW YORK

Production editor: Yvonne E. Cárdenas
Text designer: Julie Fry
This book was set in Perpetua and Futura.

3 5 7 9 10 8 6 4 2

Library of Congress Cataloging-in-Publication Data
Names: Laurens, Camille, author. | Wood, Willard, translator.
Title: Little dancer aged fourteen : the true story behind Degas's masterpiece /
Camille Laurens ; translated from the French by Willard Wood.
Other titles: Petite danseuse de quatorze ans. English
Description: New York : Other Press, 2018. | "Originally published in French
as La petite danseuse de quatorze ans in 2017 by Éditions Stock, Paris." |
Includes bibliographical references.
Identifiers: LCCN 2018002054 (print) | LCCN 2018002717 (ebook) |
ISBN 9781590519592 (ebook) | ISBN 9781590519585 (hardcover)
Subjects: LCSH: Degas, Edgar, 1834–1917. Little dancer. |
Goethem, Marie Geneviève van, 1865– | Ballet dancers — France —
Biography. | Artists' models — France — Biography.
Classification: LCC NB553.D4 (ebook) | LCC NB553.D4 A68 2018 (print) |
DDC 709.2 [B] — dc23
LC record available at https://lccn.loc.gov/2018002054

To the memory of Jean-Marc Roberts

Let the artist take heart:
the work that is misunderstood today
may be in a museum tomorrow,
looked at with respect
as the first expression of a new art.

—*Nina de Villard*

How singular the fate of these poor little girls,
frail creatures offered in sacrifice
to the Parisian Minotaur,
a monster far more terrible
than the Minotaur of antiquity,
and one that devours virgins
by the hundreds each year
with no Theseus to rescue them!

—*Théophile Gautier*

SHE IS FAMOUS THE WORLD OVER, but how many people know her name? You can admire her in Washington, Paris, London, New York, Dresden, and Copenhagen, but where is her grave? All we know is her age, fourteen, and the work she did, because it truly was work, at an age when our own children are attending school. In the 1880s, she danced as a little rat (as girls in training for the corps de ballet were known) at the Paris Opera, and what seems like a dream to many of our young girls today was not a dream to her, not the happy age of youth. *L'Age heureux* was the name of a television show when I was growing up, it featured young ballet students at the Paris Opera doing silly things. They climbed onto the roof of the Palais Garnier, I remember, and you were afraid something terrible would happen to them, a fall or expulsion from the program, because discipline was very strict. I don't remember how it all ended — happily, no doubt, given the show's title. The little dancer of 1880, though, was sent home after a few years' work, when the director grew tired of seeing her miss rehearsal — eleven times in the last trimester alone.

But the reason was that she had another job, possibly two other jobs, because the pittance she earned at the Paris Opera was not enough to feed her and her family. She was an artist's model, posing for painters and sculptors. Among them was Edgar Degas. Did she know as she posed in his studio that, thanks to him, she would die less completely than the other girls? Stupid question—as though the work counted for more than the life. It would have been no feather in her cap to know that, a century after her death, people would still be buzzing around her in the high-ceilinged halls of museums just as the fine gentlemen in the foyer of the Paris Opera did, that she would still be examined up and down and from all sides, just as she was in the seamy dives where she may have sold her body on orders from her mother—her frail body, now turned to bronze. But maybe it did make a difference, maybe she did think about it sometimes. Who can say? Surely she had heard how the *Mona Lisa* was taken to safety during the Franco-Prussian War, how it was returned to the Louvre after France's defeat, how everyone in Paris was visiting it admiringly and buying it in reproduction, thanks to the new reprographic techniques. When she posed for her employer for hours on end, growing tired in what was supposedly a "rest" position, one leg forward, hands clasped behind her back, silent, did she consider that Monsieur Degas had enough talent to make her famous too, that her little walk-on role would one day make her a star? Did she imagine such a future for herself—a

fame that the ballet world would never grant her? It's possible. After all, little girls do have their dreams.

What I hope, as I look at her in triptych on a post-card—back, front, and profile—bought at the Metropolitan Museum of Art in New York, is that she was oblivious to all that was said about her during the first exhibition of the *Little Dancer*. Although it wasn't exactly said about her. Do you know the story of Cézanne's portrait of his wife? Some people stopped in front of it and said, "What a hag!" while others said, "What a masterpiece!" Which counts for more, the painting or the model, art or nature? Does the work of art console us for what happens in life? Certainly, the little dancer was not expounding on the relation between actuality and representation. Nor was anyone else. On that April day in 1881 when the figure was first exhibited at the Salon des Indépendants, there were few who made the distinction. Esthetes and society ladies, critics and amateurs, all crowded together in front of the sculpture, made more impatient by the fact that the sculpture had been announced for last year's show but inexplicably withdrawn. And this year, Degas had brought it to the exhibition late, fourteen days after the opening. An empty glass case, the subject of much speculation, stood in as a placeholder, while rumors circulated that the sculpture would not be in marble or bronze, nor even in plaster or wood, but in wax. Normally, wax is a stage in the process of making the final work, but the artist was choosing here to exhibit it as the end product. And

it would be dressed in real clothes, like a doll. Wearing actual ballet slippers. What an oddity! All the same, this wasn't the official Salon but the exhibition mounted by the splinter group of the Indépendants, the so-called Impressionists, who had never been very academically minded, so it wasn't all that surprising. Other than a portrait carved in wood and a small bronze by Paul Gauguin, *La Petite Parisienne,* Degas's *Little Dancer was* the only sculpture in the show. Finally, the public was getting a chance to see it! In the midst of canvases by Pissarro, Cassatt, Gauguin, the figure stood in a glass case, which further piqued curiosity. They pressed forward eagerly, approaching their faces, their monocles, to the transparent divider; they frowned, they backed away, what the devil, hesitated, and either fled or stood transfixed. Almost all who saw it, sensitive and cultured as they were, reacted with horror to the *Little Dancer.* This isn't art! some people said. What a monster! said others. An abortion! An ape! She would look better in a zoological museum, opined a countess. She has the depraved look of a criminal, said another. "How very ugly she is!" said a young dandy. "She'll do better as a rat at the Opera than as a pussy at the bordello!"[1] One journalist wondered, "Does there *truly* exist an artist's model this horrid, this repulsive?" A woman essayist for the British review *Artist* described her as looking "half idiotic," "with her Aztec head and expression." "Can Art descend any lower?" she asked.[2] Such depravity! Such ugliness! The work and the model were conjoined in a

single tide of disapproval, a wave of hostility and hatred whose virulence surprises us today. "This barely pubescent little girl, a flower of the gutter," had made her entry into the history of artistic revolutions.[3]

Once on view, the *Little Dancer* was exposed — as was the little dancer who modeled for Degas — to public stares and condemnation, to esthetic tastes and moral distaste. Both the sculpture and the girl came in for more contempt than admiration on that day. No one had asked her, a poor girl whose body was her only asset, for permission to put her at risk — at risk of displeasing and being demeaned. The shame of humiliation. It's true that in all likelihood she was not invited to the Salon des Indépendants. She probably never visited the sculpture during the exhibit's three-week run on the boulevard des Capucines, not far from the Paris Opera. One or another of the ruffians and grisettes she associated with, however, may have passed along the news in mocking tones: "Everyone is running off to admire you. Are you really the new Mona Lisa?" But her modeling sessions for Degas were already a distant memory. So many things had happened since, and she was now sixteen. What was the point in looking back? Besides, the exhibition hall wasn't open to the poor, to working-class women, or to prostitutes. No one congratulated a model for her patience, her immobility, her selflessness. Possibly for her beauty, if she was the artist's mistress. But that was all. Marie had not slept with Degas, as far as we know. She hadn't read the accounts in the

newspapers either—she'd been obliged to leave school early and barely knew how to read or write. The sculpture received few favorable reviews. The nicest came from Nina de Villard, companion to the poet Charles Cros, who visited the exhibition and wrote: "I felt before this statuette one of the strongest artistic sensations I've ever experienced: I have long been dreaming of exactly this."[4] Marie wouldn't have seen the review. And no one would have read her Huysmans's encomiums, directed at the artist in any case, not at her. The critic praised Degas for acting boldly, for overthrowing all the conventions of sculpture, "all the models endlessly recopied over the centuries"[5] to produce a work "so original, so fearless…truly modern."[6] But Huysmans was pitiless in his description of the little dancer, with her "sickly, grayish face, old and drawn before its time."[7] I like to think that in posing for the great artist with that defiant air, which the critic Paul Mantz characterized in the following day's *Le Temps* as "bestial effrontery,"[8] Marie foresaw the scandalized reaction of the moneyed set and responded to it in advance with that look of insolent detachment. And I like to believe that it speaks of her freedom, rising above all hindrances, a twin to Degas's own, yet very much hers, calm and nearly smiling, chin up, her personal freedom.

When the stormy Salon of 1881 closed, Degas brought his *Little Dancer* home and never showed it again to anyone. It didn't travel to the great Impressionist exhibition organized by Durand-Ruel in New York in 1886. It

gathered dust in a corner of the studio, visibly darkening, piled up among other sculptures, its tutu in shreds, next to ballet slippers and photographs of dancers. But the sculpture still figured in the thoughts of Degas's contemporaries. In the 1890s, Henri de Régnier and Paul Helleu would discuss the *Little Dancer* with the poet Stéphane Mallarmé. Artists such as Maurice Denis, Georges Rouault, and Walter Sickert mentioned it long after its disappearance from view. In 1903, Louisine Havemeyer, a shrewd American collector and future suffrage activist, offered to buy it from the artist: the scandalous *Little Dancer,* by her absence, had become cloaked in mystery, a legend. Degas refused. He wanted neither to sell the sculpture nor to have it seen. Mrs. Havemeyer, on advice from Mary Cassatt, repeated her offer several times, but Degas resisted the pressure and kept his small statue. He reworked it a little, pondered the possibilities, returned to it: "I must finish this sculpture, even if it puts my aged life at risk. I'll continue till I drop—and I still feel quite steady on my pegs, despite having just turned sixty-nine," he wrote in a letter dated to the summer of 1903.[9] Friends suggested that he have bronze casts made, since wax was eminently fragile. Either Degas lacked the funds to do this, having by this time lost his fortune, or he wanted to stay in tête-à-tête with the original—or both—but he never followed up on the suggestion. Possibly he was applying to his own work an observation he had once made on a Rembrandt painting that the Louvre planned to restore: "Touch a painting!

But a painting is meant to die, time is meant to walk over it, as over everything else, whence its beauty."[10]

It was only after his death in 1917 that more than 150 wax statuettes, found at his home in a greater or lesser state of deterioration, were given conservation treatment, the *Little Dancer Aged Fourteen* among them. But Degas's close circle did not let time walk over the *Little Dancer*. After hesitating about whether to restore it for sale as a unique piece, the family decided to send it to the A. A. Hébrard foundry in Paris. There, thanks to the painter Paul-Albert Bartholomé, a friend of Degas, twenty-two bronze casts of the *Little Dancer* were made, after an initial plaster mold, then patinated to better imitate the original wax, and finally dispersed to various museums and private collections. This quick and dirty decision by Degas's heirs, which showed little respect for the artist's personality and wishes, was seen by some as a betrayal. Yet making reproductions of the original did not, as Mary Cassatt had feared, detract from the work's artistic value, and the casts were remarkably faithful. Looking at auction catalogs, we learn that one cast, which included the original clothes, was sold in 1971 for $380,000. Another was auctioned at Sotheby's for more than £13 million. The work has inspired investors. At the start of the twenty-first century, Sir John Madejski, owner of the Reading Football Club, bought the sculpture for £5 million and sold it five years later for £12 million. We won't editorialize on the gross unfairness of the worlds of art and finance, knowing how many

painters ended up in mass graves whose works now slumber in safe-deposit vaults.

Degas always lived off his painting. He was also a voracious collector—Ingres, Delacroix, Manet, Pissarro, Daumier, Corot, Sisley, Hokusai, Van Gogh. At his death, he owned, warehoused in his home, more than five hundred masterpieces and thousands of lithographs. But he despised money. His father was a banker who had gone through bankruptcy, and Degas hated to see a work of art treated as a "luxury item" when to him it was an "item of primary necessity."[11] He sold single pieces—grudgingly and at high value—when he needed the money, and he mocked his colleagues fiercely for pursuing medals, honors, and emoluments. When it came to the *Little Dancer*, the administrators of the French national museums paid scant attention to the original wax version: it was allowed to leave the country for $160,000. Bought in 1956 by an American citizen, Mr. Paul Mellon, it has been in the United States ever since, a development Degas might have approved of, since he himself spent time in Louisiana, where his mother was born and a part of his family lived. He adored sprinkling his conversation with English words and would probably not have objected to the expatriation of his work, having considered emigrating himself at one point. In Paris, only one posthumous bronze casting with tutu and ribbon is on view—at the Musée d'Orsay. You can always pick up a reproduction in synthetic resin on the Internet for twenty dollars or so. And there are postcards, of which I have bought many

over the years, long before I ever planned to write this book, just because I liked the little dancer. I've always liked her, she intrigues and moves me. Her image has accompanied me for a long time, it sits on my desk, my shelves. She has her nose in the air, not looking at me, but I feel her close all the same, observing me though in a different way. Every time I enter a museum where she is on view and to which, for some still secret reason, I've come expressly to see her, I feel my heart leap.

1

Truth is never ugly, when you find in it what you need.

—*Edgar Degas*

I have locked away my heart in a pink satin slipper.

—*Edgar Degas*

HER NAME WAS MARIE GENEVIÈVE VAN GOETHEM. Her parents were Belgian. They had emigrated to Paris to escape poverty like so many of their countrymen—and so many others from Italy and Poland—and had settled at the foot of Montmartre in one of the poorest neighborhoods in the city. Her mother was a laundress, her father a tailor. Marie was born in Paris on June 7, 1865, the second of three sisters. The eldest, Antoinette, had been born in Brussels in 1861 and posed for Degas first, starting at age twelve. She went on to become a prostitute and, driven by hunger, a petty thief, working alone or with her mother, and she eventually served time in the Saint-Lazare prison for women. The youngest, Louise-Joséphine, joined the Paris Opera as a "little rat"

at the same time as Marie. Of the three, she had the least tragic life: she was selected for the corps de ballet and later became a successful dance teacher — one of her pupils was the great Yvette Chauviré. It's always intriguing with siblings to see how fate works different embroideries on the same canvas of sufferings. The youngest, less brutalized by their aging mother, perhaps had the advantage of a more moderate temperament, or else loved dance sufficiently to carve a place for herself in that world, turning a constraint imposed by her mother into an avenue of salvation.

Degas might have met the sisters — or their mother — around the Paris neighborhood where they lived. During the twenty years from 1862, when they arrived in Paris, to 1882, when we mostly lose track of them, the Van Goethem family was registered at seven different addresses, always in the Ninth Arrondissement, near the place Pigalle. These successive moves likely reflect that they were skipping out on their rent after missing several payments in a row and finding the landlord increasingly insistent or else that they were trying to escape charges of prostitution. Degas also relocated several times while staying in the same general area — rue Blanche, rue Pigalle, rue Fontaine, rue Ballu, and boulevard de Clichy, where he lies buried today, in the Montmartre Cemetery. That part of Paris was also where the greater part of bohemia lived, alongside workers, shopkeepers, and employees — a stratum of society known in French as *la blouse*, for the loose-fitting smock its

members often wore at work. Degas felt comfortable there, and often wore the smock himself, as did many painters, and was photographed in it. But he wasn't poor, he didn't live in a garret, and he didn't lead the bohemian life immortalized in the opera by Puccini and the biopics about Modigliani. He was a well-off and somewhat conservative bourgeois who, at the start of the 1880s, occupied the fifth floor of a new apartment building and rented a handsome studio in the courtyard. His family took pride in belonging to the petty nobility, but he had altered his name from "de Gas" to the more plebeian "Degas," which even became, in the phonetic rendering of the visitors' register to the backstage of the Opera, "Degasse." The replacement of the noble particle *de* by a vulgar prefix did not strike him as a loss of status. When the concierge at the Paris Opera, not knowing who was who, made fun of the top-hatted toffs who came to visit the young girls, he would have rhymed "Degasse" with *radasse* and *pouffiasse*, two slang words for women of low morals that were then gaining currency in bohemian Paris.

Yet at the point when Antoinette van Goethem and then Marie began posing for him in the mid-1870s, Degas—despite his early fascination with dancers and singers, whom he went to see regularly, and despite his reputation as, in Manet's words, "the painter of dancers"—had not yet received permission to wander freely in the backstage area of the new Paris Opera. The old Opera building on the rue Le Peletier had

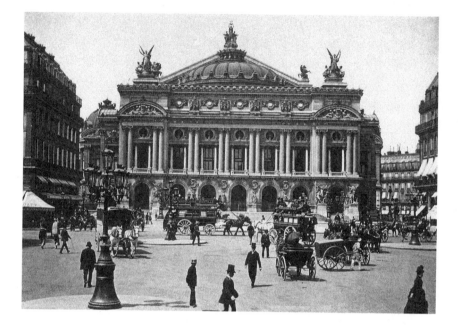

been destroyed by fire, the Palais Garnier had just been inaugurated, and the pass that would allow Degas free entry via the service door to attend rehearsals would only be granted him in 1885, in return for his buying a subscription for three shows a week. In 1882, requesting access to the rehearsal space to attend a dance examination, Degas wrote, "I've painted so many of these examinations without ever having seen one that I'm a little embarrassed."[1] He may have insisted that the main part of painting was performed "by memory," but he still needed time in front of the subject[2] and often hired models to pose for him at his studio, sessions that produced a profusion of sketches and studies.

Until about 1880, he had essentially been a painter. But in the past few years, his eyesight had started to fail. Already in 1870, when he joined the infantry during the siege of Paris, he had noticed that he couldn't see the target with his right eye. A long spell in a cold, damp attic had apparently damaged his eyesight irreversibly. He was barely forty years old, but already he was half blind. Highly sensitive to light, he was easily recognized around the capital by his blue-tinted eyeglasses. For a painter, this was a cruel fate. "Sculpture," he explained to the gallerist Ambroise Vollard, "is a blind man's trade."[3] From being a desire, it became a necessity. His hand would henceforth function as "an additional eye,"[4] the sureness of his touch would make up for the growing inaccuracy of his vision. But Degas's turn toward sculpture was not simply a response to circumstances. It

also corresponded to his search for greater truthfulness: "I realized that for an exactness so perfect that it gives the sense of life, one has to resort to three dimensions."[5] Since his primary objective was—as in his paintings—to capture pure movement, wax became his preferred medium. He could model it easily and indefinitely, while marble or granite, materials destined "for eternity," did not allow "the hand to approach the idea."[6] And wax was the substance that most closely imitated flesh.

MARIE VAN GOETHEM, the mother of Marie Geneviève, was a laundress, just as in a Zola novel—or rather, the reverse, since the author of *L'Assommoir* and *Nana* would admit to Degas that in certain passages he had "quite simply described" Degas's paintings.[7] Van Goethem *mère* led a hard life, slaving for pennies. The father, Antoine, was long gone, either dead or returned to Belgium. Life expectancy in the lower-class neighborhoods barely reached forty. Absinthe often cut lives short.

Having three daughters was both a plague and a boon to someone without money. You could always sell them. Childhood was not a defined sociological category in the nineteenth century, nor did it benefit from legal protection, and children could be exploited to differing degrees. The first recourse was to set them to work at something perfectly legal. This Marie van Goethem did in pushing her daughters to join the Paris Opera. She no doubt negotiated a group contract: sets of sisters

were quite common. This was not the same as a mother enrolling her daughters in a ballet class, or even getting them an audition to see if they had talent. Rather, it was a terse bargaining session, leading to an employment contract that the mother would sign with an unsteady scrawl or a cross. The Jules Ferry Laws of 1881 and 1882, which would make primary education free and publicly available and later compulsory for all children ages six to thirteen, had not yet been enacted. The Paris Opera, in any case, would be exempted from those laws, and primary school would only become mandatory for the young girls at the Opera in 1919. The writer Théophile Gautier wrote an incisive but little-known text on this subject, "Le rat" (The Rat). In it, he bemoaned the total ignorance of these "poor little girls" who barely knew how to read and who "would do better to write with their feet, which are more highly trained and more adept than their hands."[8] These deprived girls never received any formal schooling and were obliged to earn, if not their living, at least their board. The majority had never known their father and provided the main support for their families. Boys could rent out their arms to work in the mines or on the farm; girls rented out their legs, their bodies. The Paris Opera recruited "little rats" as young as six years old. These would later come to be called *marcheuses*, "walkers," because they spent all their time performing steps, first in the dance class, then onstage, where they would make their first appearance at thirteen or fourteen — Marie would make

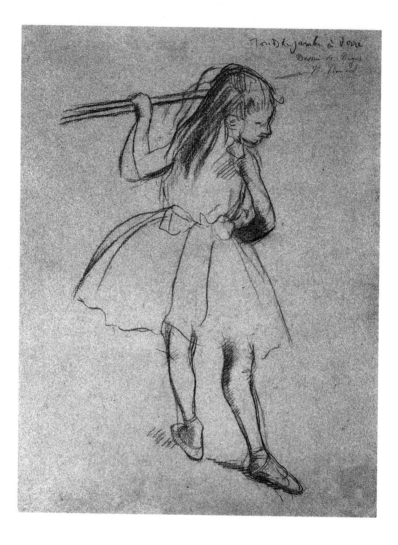

her walk-on debut in *La Korrigane,* a ballet in two acts.
Théophile Gautier was quick to make fun of the nick-
name "walkers," which suggested the profession the
adolescents would soon adopt on the city's sidewalks.
The beginners earned two francs per day, a very small
sum, but still twice what a miner or a textile worker
was paid. Parisians had not forgotten that only a few
years earlier, during the winter of 1870, when the capital
was under siege by the Prussians, two francs was the
price of a rat, a real rat—a cat would cost eight francs,
while the elephant and the camel slaughtered at the Jar-
din des Plantes cost several months' salary, a luxury only
the rich could afford.

Opportunities for advancement at the Paris Opera,
both social and economic, were real but also rare, and
subject to biannual examinations that were both costly
and difficult. For her performance before a jury, a
dancer had to buy her tarlatan skirt, her silk ribbons,
and the artificial flowers in her hair. Over the years,
the more talented students rose through the ranks and
received better pay; each public performance earned
them a small bonus, which was added to their mea-
ger salary. If they passed the exam, they moved up
from the dance school to the corps de ballet, then to
the rank of featured dancer. Only at that point would
they sign a firm contract, usually for fifteen years. Of
the rats, only a minuscule number earned fame. Every
mother dreamed of glory for her daughter, but most
had more pragmatic goals. They were often widows or

single mothers from working-class backgrounds, and they bombarded the director of the Paris Opera with pathetic letters (dictated, of course), pleading for "protection" for their daughters—no one was in any doubt what sort of protection a man might offer a woman. An auxiliary source of income was therefore available to the little Opera rat, and the practice was tolerated if not explicitly endorsed. What would be denounced today as pedophilia, pimping, and the corruption of minors was at the time normal practice, when "the prevailing moral code was a total lack of moral code."[9] Besides, children reached sexual majority at the age of thirteen, according to an 1863 law—the age had previously been eleven. Backstage, procurement was the quasi-official function of a mother, who was expected to "present" her daughter to male admirers. The police shut their eyes to it, as did the Opera administration. Those who reserved seats in the orchestra or private boxes in the balconies, the "subscribers," had the free run of the foyer, the backstage area, and the private drawing rooms, which became trysting sites. Others, less fortunate and unable to obtain the privilege, waited in the hallways, the vestibules, and at the exit. "I adore the dancers' mothers," said the librettist Ludovic Halévy. "One always learns something from them…They have entry into every world. During the daytime they are fruit sellers, seamstresses, and washerwomen, but at night they chat familiarly at the Opera with our most eminent men."[10] It is entirely likely that Marie's mother played the role

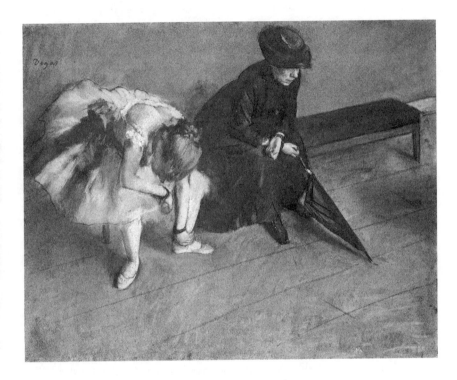

of procuress and agent for her daughters. Shortly before Marie left the Opera, there was mention in *L'Évènement,* a newspaper that carried gossip about the world of dance, of "Mademoiselle Van Goeuthen [*sic*], fifteen years old. Has a sister who is a walk-on and another at the ballet school. Poses for painters."''' The reporter adds that Marie frequented the cafés around Montmartre and ends: "Her mother ... No, I can't go on ... I would say things that would make you blush — or cry." Perhaps the mother also prostituted herself, but it seems certain at least that she, like many others, encouraged her daughters at a very young age to find a rich protector. Balzac, in the following scene about a man from the provinces freshly arrived in Paris, offers a prototypically Parisian tale:

> "Well, well," he said, pointing his cane at a pair of figures emerging from the alley by the Paris Opera.
>
> "What is it?" Gazonal asked.
>
> "It" was an old woman in a hat that had aged six months on a store shelf, a pretentious dress, and a faded tartan shawl, whose face showed the ravages of twenty years in a damp lodging, and whose bulging market bag announced a social position no better than ex-doorkeeper; beside her was a slender, willowy young girl, whose black-lashed eyes had lost their innocence, whose complexion spoke of great fatigue, but whose face, prettily shaped, was fresh, surrounded by a mass of hair, her forehead charming and bold, her chest flat — in a word, an unripe fruit.

"That," said Bixiou, "is a rat, accompanied by its mother."

"A rat?"

"This rat, just released from her rehearsal at the Opera, is returning home to a meager dinner and will be back in three hours to put on her costume, if she's dancing tonight, because today is Monday. This rat is thirteen years old, already ancient. Two years from now, this creature will be worth 60,000 francs on the public square. She will be nothing or everything, a great dancer or a *marcheuse*, a famous celebrity or a vulgar courtesan. She has worked since the age of eight. As you can see, she is crushed with fatigue, having worn out her body this morning in dance class, and she is emerging from a rehearsal where the sequences are as hard as the moves in a Chinese puzzle. But she'll be back again tonight. The rat is one of the constituent elements of the Opera. She is to the prima ballerina as a clerk is to a lawyer. The rat is hope."

"Who produces rats?" asked Gazonal.

"Porters, actors, dancers, the poor," said Bixiou. "Only the most desperate poverty could convince a child of eight to consign her feet and her joints to such severe torture, to stay obedient until the age of sixteen or eighteen, entirely on speculation, and to have always at her side a ghastly old crone, the way you might encircle a lovely flower with manure."[12]

In branding the foyer of the Opera as a prime locus for licentiousness, Théophile Gautier went even further, describing the sexual trafficking, the "lurid nights of

evil and orgies," for which mothers gave their daughters "lessons in suggestive glances" before selling them. "Not all the slave markets are in Turkey," he noted.[13]

MARIE VAN GOETHEM, then, joined the Paris Opera. The terms of the contract for such a spindly girl would have been harsh. She worked ten or twelve hours a day, six days out of seven, going from ballet class to rehearsals to performances. The 1841 law setting a limit on the length of a child's workday did not apply to the Opera. The ballet school stipulated in its regulations that a student must absolutely live within two kilometers of the Palais Garnier, because the daily stipend of two francs would not cover the cost of a tram or omnibus: Marie came on foot every day—and it is likely that she never ventured beyond her neighborhood during her childhood. The director was all-powerful, and the least absence was a pretext for fines, culminating in dismissal—which required the guilty party to repay one hundred francs for each unfulfilled year of her contract. This is what happened to Marie, who was fired for absenteeism before her contract expired—but how could she ever find so much money in one place? It was just to make a little extra money that she had missed her classes in the first place.

Her daily life was one of hardship. She arrived at the Opera early in the morning and spent hours in class and at rehearsal, under the vigilant eye of despotic teachers:

Mérante, the ballet master, who was known for his sadism, and the much-feared Monsieur Pluque. Marie was small and slight, the exercises exhausted her. The first order was to limber up at the barre, then to move out onto the parquet floor, regularly sprinkled with water, and string together the same movements: jetées, pirouettes, entrechats, ronds de jambe, fouettés, steps *en pointe*...She tired easily, not least because the food she ate was insufficient and of poor quality—and sometimes lacking altogether. She was threatened with having her legs and her back encased, as in the old days, in a sort of wooden box that was intended to correct faulty positions. She was forbidden to complain, to speak, to laugh, to cry. The musical accompaniment—played on the piano or the violin—and the breaks between sessions offered small crumbs of consolation over the course of a strenuous day. Chatting, laziness, and ill humor were infractions that received prompt punishment. When Marie's mother attended class, sitting on a bench with the other biddies—she found occasional work at the Opera as a dresser—it was even worse, because scoldings then rained down on Marie from all sides. Her corset and tutu were worn, her hand-me-down cotton slippers were misshapen and had been repaired twenty times already. Her feet were often bloody and her poorly tended sores infected. When she arrived home at the tiny apartment she shared with her family, there was no running water. She couldn't wash her sweaty body until the concierge saw fit to bring water, unless she went

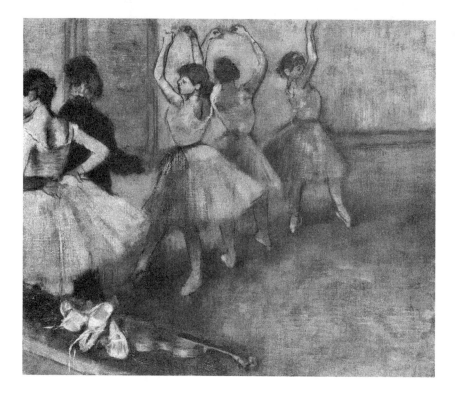

back downstairs herself, got in line at the water pump, and lugged the bucket back to the apartment without spilling. The public baths were expensive, and she could barely afford them once a month.

Did she have friends and playmates, as other children do? Sisters in misery, more like. Apart from a few girls of the French or foreign bourgeoisie who were grudgingly allowed by their parents to live out their love of ballet in this celebrated but highly suspect world, most of the Opera rats were driven to the work by necessity. Girls who weren't admitted to the corps de ballet worked as walk-ons for a few centimes — the eldest, Antoinette, did this on several occasions. If they had no "protector" among the male subscribers to the ballet, because of not being especially pretty or skilled at gallantries, they suffered the worst privations and lacked even the funds to pay the dentist or the doctor when they were ill. Some came to a bad end — the story of Emma Livry was told in hushed tones, the girl who burned to death during a performance when her tutu caught fire from a gas burner in the wings. A number of girls, though barely fifteen years old, were already alcoholics — it was tempting to get tipsy milling with the crowd in the Opera's foyer. Others died of tuberculosis. The class for the youngest girls was still fairly joyous and unrestrained, but as soon as the girls reached adolescence they acquired a blank gaze and a look of resignation, entering a life of prostitution without ever having been children. "The Opera rat is caught in the gigantic mousetrap of the theater

at such an early age that she has no time to learn about human life," wrote Théophile Gautier.[14] A few, true enough, pursued their vocation assiduously and became great dancers, Marie Taglioni among them, whom Degas painted and even celebrated in verse. And if a subscriber took an interest, paying for a girl's private lessons, a little rat might rise above her condition. It happened with Berthe Bernay, who joined the Paris Opera a short time before Marie van Goethem at six hundred francs a year and who, thanks to hard work, ended up a star with an annual salary of 6,800 francs. Others with less talent but endowed with grace made a career as courtesans of the demimonde and lived in luxury. And others yet, like Marie's younger sister, retired from the stage after they reached thirty and became ballet masters. But all the rest, the great majority, were never more than little rats, swarming here and there in an unhealthy environment. Their nickname speaks to their true condition. Although some dubious etymologies claim otherwise, the name was applied most likely as a metaphor for their existence. In the words of a former director of the Paris Opera: "The rats make holes in the scenery so they can watch the performance, gallop around behind the backcloth and play blindman's buff in the hallways. They are supposed to earn twenty sous per show, but because of the huge fines imposed on them for their transgressions, they receive only eight or ten francs per month and thirty kicks in the backside from their mothers."[15] To other observers, the rat was mainly the transmitter

of the "sexual plague," syphilis. We are a long way from the charming and austere image projected by the Paris Opera's current crop of students. Only in the twentieth century, as the starlets of the music hall and moving pictures attracted the glare of scandal and the heat of lustful desire, did classical dancers begin to gain a measure of respectability.

Why Edgar Degas, a solid bourgeois well known for his moral severity and a man, by his own account, obsessed with order, should have become fascinated by the louche world of the dance at such an early stage in his career and stayed with it for so long—roughly from 1860 to 1890—is unclear. Was he one of the paunchy, top-hatted swains so often caricatured by Forain and Daumier who hardly stayed for the performance but took up a stand in the foyer after the first break, drinking champagne and cognac while waiting for the ballerinas? No, although as a young man—before he became an outright misanthrope—Degas had had his share of libertine adventures. Or so he liked to claim. But the aims of the lustful habitués were not his aims. He painted them, the predatory regulars, showed them lying in wait in a corner of the canvas or gathered in a group, strutting roosters in the henhouse. Sometimes he adopted their perspective, focusing in close-up on the bodies of the ballerinas. He observed these men for years. It was his world, his time, the reflection of his own desire as well, and "one can only make art from what one knows."[16] Also, Degas had a passion for music—Mozart,

Gluck, Massenet, Gounod—which supplied his original and main rationale for attending the opera. His discovery that, in subtly choreographed ballets, dance "turns music into drawing" would come later.[17] Then too, Degas was a creature of the night. Unlike the other Impressionists, and probably in part because of his eye problems, he did not seek out daylight scenes or sun-dappled luncheon parties. He preferred nighttime settings, the artificial light of theaters and cabarets, shadowy places.

That Degas should have been fascinated by dancers, independently of his male desires or his work as an artist, is not surprising. In the second half of the nineteenth century, the lives of dancers fascinated everyone, especially in Paris. Dancers belonged to the urban folklore that is so often braided into the history of great capitals. To understand the infatuation, one need only look at our contemporaries' insatiable curiosity toward celebrities, which is characterized by a similar ambivalence. Objects of admiration and opprobrium, attraction and repellence, the "young ladies of the Opera" excited interest mostly for their sexual indiscretions and their romantic entanglements. Their tutus alone were a source of scandal and comment. Though longer than today's tutus, they exposed a woman's ankles and calves as no other garment of the period did. Two American ladies were reportedly so shocked that they walked out of a performance minutes after it started, seeing nothing in these short-skirted creatures but an attack on sober morals. Yet tales of the great heights to which

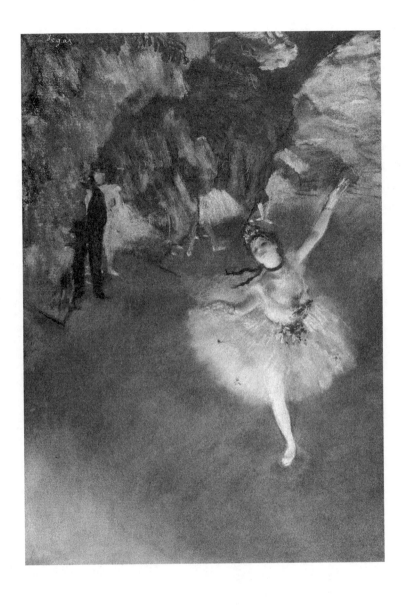

dancers rose and the tawdry depths to which they sank inspired the work of artists, writers, and tabloid journalists. These stories were avidly followed in the popular quarters and the more cosseted precincts alike. Toward 1875, the renowned librettist Ludovic Halévy published a serial novel in *La Vie parisienne* about the adventures of the Cardinal family—an early avatar of the Kardashians—recounting the romantic adventures of Pauline and Virginie, two lovely ballerinas chaperoned by their mother, a cynical procuress, who was eager to sell her fourteen-year-old daughters to aging lechers; one of the girls eventually left the Opera to become a high-class cocotte. The novel was a huge success. Degas created an accompanying series of monotypes illustrating the life of the Cardinal sisters, but they were never published, as Halévy finally opted for a more conventional suite of images. Degas depicted the young girls in conversation with their admirers and shimmering before a mirror in the Opera's foyer. He never showed them partnered by a male dancer, as though only feminine grace mattered—and men were only a foil. Other novels came out in the vein of Halévy's, usually comical in tone. One such was the adventures of Madame Manchaballe and her three little rats (who lived on the rue de Douai, as the Van Goethems did), written by Viscount Richard de Saint-Geniès, a regular at the Paris Opera, hiding behind the jocular pseudonym of Richard O'Monroy. The penny press churned out potboilers with suggestive titles: *Behind the Curtain*, and *The Young*

Ladies of the Opera. The sexualized, eroticized little rat inflamed the public imagination, appealing to men, of course, but also to women. Dance has always been the stuff of dreams, it is the romantic art par excellence, it personifies beauty, seduction, and perfection. People were riveted by the fact that it was possible to "pay 100,000 francs to a pair of ankles," to a prima ballerina "whose name on the poster draws all of Paris, who earns 60,000 francs per year, and who lives like a princess," as Balzac wrote, adding for the benefit of his visitor from the provinces: "If you sold your factory, the proceeds wouldn't buy you the right to wish her 'Good morning' thirty times."[18]

These stories fascinated the bourgeois public and frightened it at the same time. Tales of beautiful ballerinas turning the heads of eminent men and ruining their health, reputation, and career were a staple of the scandal sheets. The heroine of Zola's *Nana*, an exact contemporary of Degas's *Little Dancer*—who was in fact nicknamed "Little Nana"—had no talent as an actress. She merely stood onstage scantily clad and struck suggestive poses, but her performance so maddened men that it destroyed their lives—and then her own. She ended up disfigured by smallpox just as France was being defeated in the Franco-Prussian War of 1870, as though she stood for all that threatened the French nation, which was hopelessly in thrall to sensuality and debauch. Among respectable families of that era, a woman who worked was already suspected of depravity:

an honest woman stayed home. So what could you possibly say about an actress or a dancer? Did she not express "the imperious offer of sex, the mimed call of the need for prostitution"?[19]

Ballet dancers, as the dubious cynosure of this shady world, were synonymous with corruption and degeneracy, linked with prostitutes who might bring crashing down a venerable genealogical tree. The dancer's power was worrying: "The corps de ballet is the great power," wrote Balzac. He cited the case of "a dancer who exists thanks entirely to the great influence of a newspaper. If her contract had not been renewed, the ministry would have found itself saddled with another enemy."[20] The "walkers" often ended up in houses of ill repute—the brothel was another common motif in painting and literature—but stars of the ballet and even third-tier ballerinas lived in "the high spheres of dandyism and politics."[21] Backstage and in the foyer of the Paris Opera, aristocrats, members of the Jockey Club, influential journalists, and politicians vied for the dancer's attention. She might be mistress to a senator, or a peer of France, or a wealthy heir whose capital she was whittling away. Baron Haussmann, for instance, who masterminded the renovation of Paris, caused vast quantities ink to be spilled over his scandalous affair with a young ballerina. In that venal and hedonistic age, it was considered good form to "keep one's dancer." The sons of good families met ruin, committed suicide, or were ravaged by syphilis—all because of a dancer. In

the "conspiratorial shadows" of the theater, evoked by Julien Gracq in his writings about Nana, the dancer had the terrifying power to destroy a noble line.[22] Offering a point of contact between the lower depths and the elites of society, she braved "venereal fear,"[23] she "sowed destruction, corrupting and disorganizing Paris between her snowy thighs," she was "the fly that has escaped the slums, bringing with it the ferment of social rot,"[24] and she was therefore a source of horror and fear, more even than of admiration and lust.

Did Degas fall prey to these alternately enchanting and horrifying fantasies that held the collective imagination in thrall? It seems not. The absorbing world of ballet may have played in his mind the role that myth played in the minds of earlier painters, but we cannot reproach him for sublimating his subject or prettifying the everyday reality of ballerinas. Where Ludovic Halévy presents us with a flurry of charming imps, laughing as they fluff out their gauzy skirts, Degas rarely shows us dancers under a glamorous light. He sometimes painted performances, but his more usual perspective was from backstage. In his canvases, we see the wearying work of rehearsals, the dancer's body bent and weighted down with effort, the face tense or blurred or cropped out entirely, leaving more space for the legs and arms. This "iconoclast," wrote Huysmans, was indifferent to the shopworn image of the ravishing ballerina endowed with the flesh of a goddess, instead revealing "the mercenary, dulled by mechanical movements and monotonous

leaps,"[25] whose body was simply the tool she used in her work, and who ended up collapsed after a strenuous session, her muscles sore and her neck in pain. *The Dancing Lesson*, for example, painted in 1879, shows the ballerina Nelly Franklin sitting in exhaustion on a bench, and Degas's annotation reads "Unhappy Nelly." A little rat might often be unhappy, especially if she lacked aptitude for her vocation. In his sonnets, Degas made fun of the talentless student who flubbed a dance movement: "Jumping froglike into the ponds of Cythera."[26] And the poet Henri de Régnier, in a verse portrait of Degas, praised the painter's disillusioning art: "You've painted gauze flounces in delicate washes, / The satin slipper as it lands on the stage, / And the body's full weight on the heel that it squashes."[27] By choosing Marie van Goethem as his model, a little girl with a flat chest and pinched features, Degas drove home his point all the more. This dancer is neither seductive nor a seductress, she is wearing not a beautiful stage costume but a simple and unornamented bodice; her nose in the air, she does not look at those who look at her, she exudes no sensuality that might excite the male observer. Her position is not one of the classic positions of the ballerina, she displays no lightness, no virtuosic ease, no particular grace. She is not depicted in rehearsal or in performance but during an ill-defined break, in a practice room, making no effort to please. Paul Valéry accurately summed up Degas's paradoxical method, noting that he tried to "reconstruct the body of the female animal as

the specialized slave of dance."[28] "For all his devotion to dancers," wrote Valéry, "he captures rather than cajoles them. He defines them."[29]

What Degas shows us, in fact, is not the mythical dancer but the humdrum worker; not the idol under the floodlights but the toiler in the shadows, once the oil lamps have been snuffed out; not the object of distraction and delight but the subject grappling with a sinister reality. As his friend the painter and author Jacques-Émile Blanche wrote, under Degas's gaze, the dancers "stop being nymphs or butterflies…to fall back into their misery and betray their true condition."[30] Where Jean-Baptiste Carpeaux, ten years earlier, sculpted the beautiful Eugénie Fiocre, a prima ballerina at the Opera, as a countess or a duchess, with a rose in the elegant folds of her décolletage, and Degas painted the same Mademoiselle Fiocre as a fascinating Persian princess surrounded by her intimates, here he is offering up an entirely different vision. Marie van Goethem is only a young worker in the world of ballet, a little girl who is alone and solitary. No one is concerned about her fate. Degas depicts her in all her simplicity and destitution. The sculpture allows the emptiness around her to be suggested: no scenery, no company. You walk around a sculpture, taking it in from all sides the way you might examine a question from every angle. The "little Nana" stands against a backdrop of nothingness. Degas wanted to undermine the stereotype, assert a truth that society ignores — wants to ignore. Dance is not a fairy tale, it's

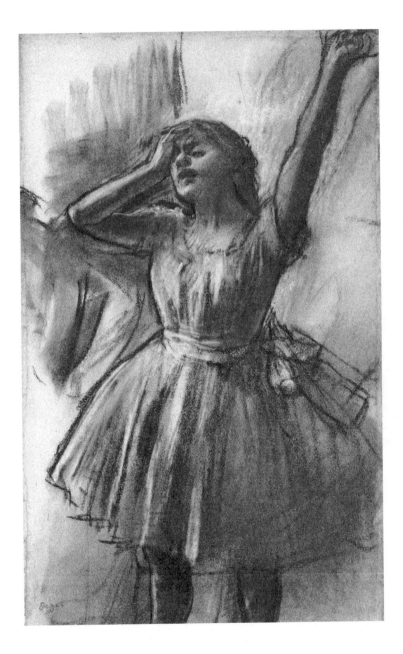

a painful profession. The little rats are Cinderellas without fairy godmothers, they don't become princesses, and their carriageless coachmen remain mice, as gray as the cotton ticking of their slippers. They are children who work, the likes of dressmaker's apprentices, child-minders, and salesgirls, but they work harder than the others. In his way, Degas was amplifying and anticipating the denunciations that the writers of his day would level at the industrial nineteenth century, when poor children were treated like slaves or animals. In 1862, Victor Hugo published *Les Misérables*, a novel that decries the tragic fate of children through the stories of Gavroche and Cosette. The despicable Thénardiers, who brutalize Cosette, owe their name to a political adversary of Hugo's, Senator Thénard, who had opposed a bill to reduce the workday for children from sixteen hours to ten. Zola would defend this cause in his novel *Germinal,* and in 1878, Jules Vallès dedicated his autobiographical novel *L'Enfant* "to all those who, during their childhood, were tyrannized by their masters or beaten by their parents."

But did Degas have such an overtly political end in mind when making the *Little Dancer*? Did he really want, as Huysmans would claim, "to throw in the face of his century" the outrages committed on the weak? There is one detail that might lead us to doubt it, hinting that the sculptor agreed at least in part with some of the prejudices of his time. Many of the detractors of this sculpture, on seeing Marie in her glass cage, thought she

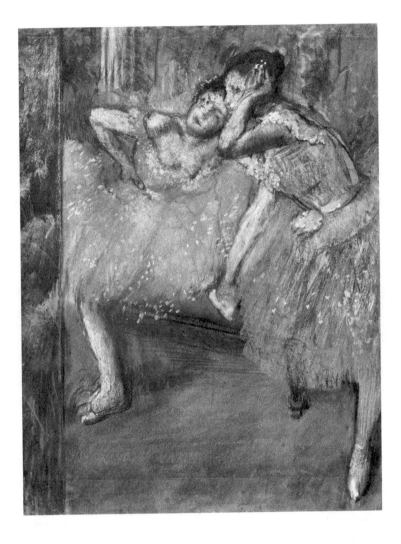

embodied "the rat of the Paris Opera...with her full store of evil instincts and depraved tendencies,"[31] that she looked "thoroughly like a pervert"[32] from the slums and had the features of a "criminal."This last word, used by several critics, might surprise and shock today's viewers. How could this young dancer in a tutu have anything criminal about her? And what is meant, in a concrete sense, by "features of a criminal"? How does one detect them? Do criminals share a facial type, different from a proper person's? Can a propensity for evil, can moral degeneracy be discerned in a person's visage—not, as in *The Portrait of Dorian Gray*, imprinted on it over time by the performance of criminal acts (itself an arguable concept), but in childhood, at the age of fourteen, as if one's fate could be tattooed at the outset on one's face? Can vice be "stockpiled" within the body, visible to the naked eye? We might as well be designated criminals at birth! Badness by nature! The idea is ridiculous.

There was nothing absurd about it to thinkers of the nineteenth century. In fact, it was the prevailing belief. In the late 1790s, Johann Kaspar Lavater's *The Art of Knowing Men by Their Physiognomy* was widely read in France and elsewhere. A German theologian, Lavater—whom some consider the father of anthropology—envisioned a link between physical appearance and a man's moral and intellectual capacity. For example, a man with a large jaw and a full-lipped mouth could be recognized as animalistic, whereas a broad, high forehead designated superior intelligence. Scientists also had a deep interest

in phrenology, a theory that purported to explain man by his physical and organic constitution. An Italian specialist in criminal ethnography, Cesare Lombroso, following in the path of the German neurologist Franz Joseph Gall, held that the degree of development of a man's faculties could be determined by the shape of his cranium, specifically its bumps and hollows. Character therefore is entirely determined by physical conformation. In French, we still say that someone has "the math bump" or "the business bump," the only remnant today of this spurious hypothesis, but during most of the nineteenth century the idea was taken very seriously. Scientists were particularly keen on its use in the context of criminology. F. J. Gall, for instance, believed he had found "the crime bump" hidden behind the ears of murderers. Scientists collected criminals' skulls, studied the organs of executed inmates, calculated "facial angle" as an index of the danger the subject posed, and measured the degree of masculinity in the faces of prostitutes—the deviance with respect to a gentle and passive femininity would explain their degeneration. The concept of the "born criminal," advanced by Lombroso, linked an inclination to murder with simian features and a sloping forehead. Other criteria in the inventory, including left-handedness, baldness, prominent cheekbones in women, and the size and shape of the ear, also offered disquieting revelations. Delinquents were considered savages, primitives. A typology of criminals was devised that considered a working-class man to be

"depraved from the cradle," a barbarian under restraint, and the slums were thought to be a breeding ground for jailhouse stock. The features of the ancient Greeks, on the other hand, represented the aristocratic ideal.

These very materialistic theories, which fed into the ideas of Édouard Drumont and his French Anti-Semitic League as well as the racial classifications of the Nazis, were largely unopposed by any countervailing arguments. Only in the late nineteenth century did the thesis emerge that criminality does not originate in a physiological predisposition or an inherited trait. A few scientists, Georges Cuvier's disciple Jean Pierre Flourens among them, did take an earlier stand against determinism, citing the role of human freedom and the power of reason. Others, foreshadowing modern sociology, insisted on the influence of environment and education in countering the tyranny of biology. Their efforts were largely unavailing, and the determinist argument prospered among intellectuals and held sway in the public sphere. France was industrializing, and its working class was growing in importance. Paris, under the influence of Baron Haussmann, was seeing its heterogeneous population shuffled together in individual buildings—the rich on the lower floors and the servant class under the eaves. The ruling classes needed to be reassured about their privileges. Small wonder that they clung to theories that "proved" the natural superiority of the bourgeoisie over the working class, the rich over the poor, whites over blacks, and men over women. Man, according to

this view, which is rife with racial and gender chauvinism, is not influenced so much by his social and cultural environment as he is determined by heredity and the laws of biology. Therefore workingmen, prostitutes, blacks, and women were naturally inferior by reason of genetic flaws or an incomplete development. Social hierarchy was justified by nature itself, with rich white men at the apex and other races, women, and the poor in the lower depths. Which is to say that Marie van Goethem, with her "Aztec" features and her young girl's poverty, belonged at the bottom of the order. To a large extent, this explains the horror that the public expressed on first seeing the *Little Dancer* when it was exhibited in 1881. The bourgeois viewer looked at the work and saw his own antithesis. His preference was for Madonnas, for refined and elegant models, or for plump, healthy young women. He could not fathom why a common, hardworking Opera rat with the face of a "monkey" and a "depraved" aspect should be the subject of a work of art. Why would you represent someone from the dregs of society, what would be the point?

The face of the *Little Dancer* undeniably has some of the features identified by the phrenologists and medical anatomists of the day as typically criminal: a sloping forehead, a protruding jaw, prominent cheekbones, thick hair. It has been reported that Edgar Degas sought out information on these physiognomic theories, which are illustrated in several of his oil portraits and monotypes of bordellos. He was not alone. Research into

physiognomy was highly admired by the writers and artists of the nineteenth century. Honoré de Balzac, for instance, owned the complete works of Lavater, illustrated with six hundred engravings, from which he chose the features for his characters according to the temperament he planned to assign them: ugly face, evil soul. Émile Zola confessed to having read all of Lombroso, who helped him understand the influence of bloodlines and the hereditary nature of degeneracy. Victor Hugo visited prisoners to see whether their criminal tendencies were etched in their faces. The artist David d'Angers, a follower of F. J. Gall, carved portrait medallions illustrating his theory of bumps. When Degas, to the horror of his audience, rendered this vision of the criminal face in full, it was immediately decried as "an ethnographic aberration" and "a monster." He acted entirely within the tenor of his times and in full awareness of the disapproval he was courting. But what was his intention in sculpting the face of his *Little Dancer* as he did?

It is always hard when an artist we admire reveals serious moral or intellectual failings, even if part of the blame lies with the "times"—"it was normal for those times"—or with a defect of character. Degas's anti-Semitism has been amply attested. He was not rabid in his beliefs, but his anti-Dreyfusard stance was vehement enough to cause a rift with his old friends the Halévys in 1897, following a heated discussion about the Dreyfus affair. Even if we believe that his animus toward

Captain Dreyfus, a Jew, owed more to his great devotion to the army than to a visceral anti-Semitism, it hardly makes him likable. Similarly, we need to review Degas's ambiguous attitude toward the opposite sex, which shows little influence of feminism. A parallel question is whether Degas believed in the fashionable physiognomic theories of his time, to the point of wanting to illustrate them by modeling his *Little Dancer's* features to resemble those of a delinquent. Did he choose her, this little working-class rat, to make her the antithesis of the young lady of good family, living proof of the eugenicist arguments of the time? Or, on the contrary, was the sculpture intended to create a needed scandal, exposing the racist roots of this pseudo-science and the abjection of society?

Several indications argue in favor of the first hypothesis. At the 1881 exhibition where he showed the *Little Dancer*, Degas also presented a study called *Four Criminal Physiognomies*. Huysmans described the subjects thus: "Animal snouts, with low foreheads, prominent jaws, recessive chins, lashless and evasive eyes."[33] The sketches show the heads of four young men indicted for murder, drawn by Degas from life while attending their trial in August 1880, at a time when he was still working on his *Little Dancer*. All of Paris shared a lively interest in the "Abadie affair," so called for the lead defendant in the case, arrested at the age of nineteen with one of his friends, Pierre Gille, sixteen, for the murder of a woman cabaret manager. A second trial followed a few

months later, centered on Michel Knobloch, also nine-teen and indicted five times already, who belonged to the Abadie band and had confessed to murdering a gro-cer's clerk. All three were sentenced to death. The hor-rible nature of the crimes and the youth of the suspects, all of them from the lower depths of society, shocked the French public and revived the topical question of juvenile delinquency. One aspect also rekindled a liter-ary quarrel. Before their arrest, Abadie and Gille had been recruited for walk-on parts in a theatrical adap-tation of Zola's *L'Assommoir*. The stage manager at the Ambigu Theater had gone scouting in some of the dicier quarters of Paris and hired these youths as perfect phys-ical specimens of the degenerate milieu Zola described. In the wake of it, naturalist writers were reproached for showcasing the ugliness of the world. They were further reviled for "depoeticizing man"[34] and taking pleasure in "tawdriness," apparently to terrify the bourgeois reader by "habituating him to the horrible"[35] and depriving him of his right to the beautiful.

But this was just what interested Degas, who con-fided to his *Notebooks* his ambition to make "a study of the modern sensibility." He was able to attend the trial regularly, thanks to one of his friends who was serving as an alternate juror. While following the trial, he drew the defendants in his sketchbook, later making several pastels.

Contemporary art historians have sought to compare Degas's portraits to the originals. During a symposium

on Degas at the Musée d'Orsay in 1988, one of the great specialists on the nineteenth century, Douglas Druick, brought together Degas's drawings and the anthropometric photographs of the accused that were made by the Department of National Security at the time of the gang's arrest in 1880 and preserved at police headquarters. The comparison shows very clearly that Degas accentuated certain facial features to bring them in line with the trending ideas of criminal ethnography. He gave the young men lower foreheads, more recessive chins, and a more animalistic aspect than they had in reality. It therefore seems that Degas wanted his drawings to reflect theories of social delinquency that he subscribed to. Remembering that he chose to exhibit his *Criminal Physiognomies* together with his *Little Dancer*, linking them by their obvious resemblance — their faces seem to attest to a hateful blood relationship — we can reasonably surmise that Degas did for his dancer what he'd done for the youths in court and altered his young model's natural features to resemble those of a criminal. Of course, she never murdered anyone, but according to Dr. Lombroso her offense was no less serious: "Prostitution is the form that crime takes in women."[36] For their power to deprave, "girls" of a certain kind were subject to the same contempt and the same efforts at suppression as murderers. And this, in fact, is how Marie was perceived by all the reviewers — as a prostitute, either actual or prospective, a painted woman. The critic Paul Mantz voiced this general feeling, attributing to Marie

"a face marked with the hateful promise of every vice."[37] And viewers compared her to a "monkey" or an "Aztec," relegating her, as Douglas Druick noted, "to the earliest stages of human evolution."[38] She was thought to look "dull" and "without any moral expression." She was likened to an animal, fit only to be "trained" for the stage. She was seen as a specimen suitable for the Musée Dupuytrcn, where wax replicas of human bodies with various illnesses were exhibited (was she not herself made of wax?) and various pathologies were displayed in glass jars (was she not herself in a "cage" made of glass?). Or she belonged in the newly opened Ethnographic Museum on the place Trocadéro.

At this juncture, we may be startled to realize that Marie van Goethem probably did not look like Degas's sculpture, that what we see is not her true face, for he also gave those features to others, to men older than she, to women in a shadowy brothel, and to a well-known cabaret singer. He probably flattened the top of her skull and altered her facial angle to make her jutting chin a kind of "plebeian muzzle," as he wrote in one of his poems. When we look at the preparatory drawings for this sculpture, we see how he changed her face to give it the hallmarks of a savage, quasi-Neanderthal primitivism, a precocious degeneracy. He literally altered her nature. The contrast with the delicate portraits Degas made of his own sister Marguerite, who had fine features, a genteel oval face, and neatly combed hair, is extreme. It is hard not to loathe this forty-something

conformist who, in modeling his wax, manipulated a very young girl for reasons that have nothing to do with art or esthetics. Art need not be an exact imitation of life, but must we accept that a young creature be sacrificed to the suspect ideology of the artist?

Yet Degas never set the artist above the rest of mankind, nor did he consider himself a privileged being. Such superciliousness would hardly correspond to what we know of him. More pertinently, it's hard to believe that Edgar Degas limited his ambition to being an ethnographer of the working-class environment. True, the critic Charles Ephrussi praised the sculpture as "scientifically exact," but was the artist's intention to pursue science? Was his aim to provide a clinical description documenting a kind of "criminal aspect" at an early stage? This is hard to believe, especially from Degas, who was so passionate about his art.

On the other hand, the artist may have had a moral goal in mind. Those who knew him well often described him as a moralist. "Art," said Degas, "is not what you see, but what you make others see." By sculpting this little dancer into a criminal, was he not holding up a mirror to the viewers who protested at the sight of her? Those who decoded the signals given by this sculpture—evil, vice, ruination—had the chance to interpret them in light of their own lives and the society around them. Might not a different fate befall this sickly child were there no men to lead her astray and no women to despise her? While Degas may have accentuated her

animalistic side, he did no less when painting the clientele of brothels—big-bellied men with sloping foreheads and porcine snouts—again with the intention of denouncing social hypocrisy. Was it not a subscriber to the Paris Opera, in a novel by Richard O'Monroy, who explained cynically: "I have a passion for the beginners, the little rats still living in poverty. I enjoy being the Maecenas who discovers budding talent, who sees beyond the bony clavicles and work-reddened hands to forecast a future flowering"?[39] It was these respectable men who, in their way, fashioned the Marie van Goethems of the world and created little "criminals"—victims, actually. And the discomfort that many visitors to the 1881 exhibition felt came from the fact of being subscribers to the Paris Opera themselves, who suddenly found the object of their private desires exposed to public view and made uglier by their own perversion. Furthermore, Degas engaged Marie van Goethem to pose for other sculptures and paintings whose meaning was altogether different. Her face, for instance, is perfectly recognizable in a statuette called *The Schoolgirl*, made in 1880, around the same time as the *Little Dancer*. A well-dressed young lady, not bareheaded this time but wearing a hat, and not in a tutu but a long skirt, carries a stack of books. Nothing shocking, nothing "venal." Here is what Marie might have become if economic necessity and social inequality had not kept her from it, although stamped with the same supposedly criminal features: a charming schoolgirl. Over the course of his

career, Degas had a number of models from eighteen to twenty years old. In choosing Marie van Goethem and in spelling out her age, Degas was underlining what should have been obvious to all: that she was a child. A little girl who had barely reached puberty, she was already a lost soul in everyone's eyes. If he chose to reveal her ugliness, knowing that the public of his day equated physical and moral ugliness, it was because he aimed to be unsettling. He wanted to show reality, not flatter the tastes of the bourgeois. And he succeeded beyond his expectations: in representing a young girl of this type, he disturbed the French in part because, recently defeated in the Franco-Prussian War, they were ready to attribute the Prussians' victory to their superior moral and intellectual education—so one might read in the daily papers, and so one might hear at café counters. The nineteenth-century bourgeois were terrified—but are not the bourgeois in every age?—at the prospect of a new generation rising after them that was devoid of principles and therefore capable of destroying them. Degas only awakened this anxiety.

In his writings on Degas, Jacques-Émile Blanche compares him to his contemporaries. He contrasts him, for instance, with Gustave Moreau, famous for his Salomes, who sought refuge in myths, symbols, and abstraction because his "small stock of humanity" kept him apart "from life and ugliness," whereas Degas took on the most seemingly vulgar subjects and extracted a beauty from them "not previously seen by painters."

Moreau and Degas, Blanche adds, were both "Savona-rolas of esthetics," zealous workers in service to per-fection of form. But esthetics did not lead to the same endpoint for both. Gustave Moreau worked to captivate and seduce. By contrast, Blanche wrote, "Degas did not seduce, he frightened."[40] And because Degas was well-born, his provocations carried all the more weight. To unsettle so as to stimulate thought, to make art that was critical and served truth, though truth might be cruel, such were the aims of Edgar Degas, in his extreme modernity. He said as much in his *Notebooks*, writing about Rembrandt's *Venus and Cupid*: "He has introduced that element of surprise which provokes us to think and awakens our minds to the tragedy inherent in all works where the truth about life is bluntly expressed."[41] Surely the same applies to the *Little Dancer Aged Fourteen*. Degas intended this sculpture to give a sense of surprise, a sal-utary shock, opening the viewer's mind by presenting not an elegant work that would flatter his esthetic sense but a societal tragedy, to which he was contributing. The earliest critics of the work did, in fact, react with terror. Here is Louis Énault: "She is absolutely terrifying. Never has the tragedy of adolescence been represented with more sadness." For Degas, "the truth about life" was not to be found, as Michel Leiris would say about a cer-tain kind of estheticizing literature, in the "vain graces of the ballerina," but in the tragic and already deter-mined—tragic because already determined—destiny of this very young girl. Truth was the foundation block of

modernity. Cézanne must have had this in mind when, in 1905, he made his famous promise to Émile Bernard: "I owe you the truth in painting, and I will tell it to you."[42]

As to the "element of surprise" that he admired in Rembrandt, Degas achieves it in this sculpture not from the commonness of the subject or the reference to social misfortune alone. The manufacture of the work was in itself a great source of surprise and astonishment. In the first place, the Parisian public of the nineteenth century was not used to seeing wax sculptures — where were the marbles of Rodin, the bronzes of Carpeaux? True, specialists would have known the figurines of Antoine Benoist, notably his portrait of Louis XIV in Versailles, but these "wax puppets," as La Bruyère called them, had been out of fashion since the end of the seventeenth century. A few polychromed statues had attracted the interest of collectors, but they were little known to the general public. And aside from two or three Madonnas, also dressed and wearing makeup, in a few scattered churches, the visitor would never have seen a statue wearing real clothes and a horsehair wig — or could it possibly be a wig made of real human hair? More accurately, the visitor would have known such objects, but not in the context of an exhibition hall dedicated to art, not shown as a work of sculpture. He would have seen wax figures of humans at the milliner's, in the dress shop, and in the windows of the early department stores. He would have seen them at the Musée Dupuytren, in the Cordeliers Convent, which displayed reproductions of

human bodies affected by a variety of pathologies, malformed fetuses, likenesses of murderers, and anatomical wax models displaying terrifying venereal diseases. He would have seen them at fun fairs, as entertainment, and at universal expositions, in the context of colonial ethnography—this is how he would have learned what the indigenous peoples of far-off countries looked like. He would have seen them at Madame Tussaud's in London, the first museum to showcase life-sized wax sculptures that perfectly replicated the features, aspect, and clothing of famous figures. He would have seen them from 1865 to 1867 at the Musée Hartkoff, on the passage de l'Opéra, and at the Musée Français on the boulevard des Capucines, where the model-maker Jules Talrich exhibited statues of literary and mythological characters. And, the following year, he would see them at the Musée Grévin, which was patterned after Madame Tussaud's. As in London, the museum revived the ancient tradition of wax death masks, but using contemporary models, life-sized, in their full glory and their best finery. The Musée Grévin even featured one of the famous dancers at the Paris Opera, the Spanish star Rosita Mauri, wearing one of her ballet costumes. Her likeness was among those chosen for the museum's inaugural show in June 1882.

But in the Salon des Indépendants, the viewer felt almost offended. He hadn't gone to the fair or to the toy store, hadn't gone to the milliner's. He wasn't attending a universal exposition, in search of exoticism; nor had he come to be frightened by anatomical monstrosities.

No, he was there to discover works of contemporary art. And what did he see in a glass case, presented on a satin cloth as though it were an ethnographic curiosity or artifact? A doll, a common wax doll! Somewhat larger than an ordinary doll, maybe—the sculpture measured just over three feet in height, the size of an average three-year-old—not as pale in color as a doll, nor as closely imitating human skin, but entirely unworthy of a sculptor. Would Rodin ever have thought to gussy up his statues in this way? Insanity. In his review, Huysmans harked back to the polychrome sculptures of Spain, assigning a sacred dimension to the *Little Dancer* by comparing it to the Christ in the Burgos Cathedral, "whose hair is actual hair, whose thorns are actual thorns, whose drapery is actual fabric,"[43] but the link was tenuous. And Degas's dancer was in no way as attractive as the Tanagra figurines that had been on view at the Louvre for the past dozen years. Certain art historians noted that the lost-wax technique Degas used had been invented by the bronze casters of ancient Egypt, who also colored their sculptures, thus linking the *Little Dancer* to the *Seated Scribe*, one of the Louvre's masterpieces. But for the public as a whole, the sculpture stood outside the artistic tradition as an object of popular culture, like the dolls that had been mass-produced since the middle of the century. And when you thought about it, there were many dolls more beautiful than this one, hand-painted, with silky hair and eyes of colored glass. Some were even automated. Among the displays of new

technology at the Universal Exposition of 1878 were a variety of dolls: a Gypsy that danced, a little girl who walked, and a crying baby. The French of that period had a passion for dolls, and they figure in many paintings by Renoir, Gauguin, Pissarro, and Cézanne. Little rich girls had a good laugh or a good cry (as I did a hundred years later) reading the Countess of Ségur's *The Misfortunes of Sophie,* in which the little heroine treats her wax doll to a hot bath and watches in horror as the doll melts away! The doll that Jean Valjean gives to Cosette in *Les Misérables* has left a deep mark on the book's more self-possessed readers and brought everyone else to tears: "Against a backdrop of white napkins, the shopkeeper had placed an enormous doll, almost two feet tall, wearing a pink crêpe dress and a golden crown of wheatears, with real hair and enamel eyes. All that day, this marvel had been displayed to the wonderment of passersby under the age of ten, and yet there was not in Montfermeil a mother sufficiently rich or sufficiently extravagant to offer it to her child."[44] Cosette's love of dolls was shared by the Parisian public. The manufacturer Montanari made a fortune turning out wax dolls and figurines; the Schmitt and Jumeau companies competed to create the most ingenious mechanisms, the most realistic costumes — Indian, Mexican — thereby flattering the public's taste for ethnographic curiosities and exoticism. According to Degas's first biographer, Paul Lafond, the artist kept a collection of Neapolitan dolls in traditional costume in his dining room. He attended

the puppet theater in the Tuileries Gardens regularly. He did not hide that he had thoroughly studied the fabrication of dolls, as well as the mechanisms of automatons and the research on locomotion by Étienne-Jules Marey. He also revealed that he had consulted Madame Cusset, a famous wigmaker, to make his dancer a beribboned ponytail. But once again, the public questioned what this had to do with the fine arts. The art critic George Moore, who was a great admirer of Degas's wax sculptures, would later offer this comment: "Strange dolls—dolls if you will, but dolls modeled by a man of genius."[45] Meanwhile, the controversy raged.

And then, finally, this clothed sculpture struck visitors to the exhibition as obscene. While they went into ecstasies over the *Venus of Milo* and many other statues of women with exposed bodies, Rodin's dancers among them—here was another sculptor fascinated by the movement of dancers—they found the clothing that covered the *Little Dancer* shocking. Because if she was wearing clothes, it meant that she was naked *underneath*! The model posed naked, as was the custom in many ateliers and art schools, and normally this was either ignored or accepted on the grounds of the higher interests of art. The nudity of classical statuary shocked no one. In painting, of course, there had been recent and memorable scandals, starting in 1863 with Manet's *Olympia* and his *Déjeuner sur l'herbe*, in which the naked woman in the foreground looks at us mockingly. And there was Courbet. Contemporary naked women

who were not Eves, not goddesses, not allegories of Truth, but women of today, ones you might meet in the street, that is what was intolerable to the public. The garments ornamenting the *Little Dancer,* paradoxically, pointed to her essential anatomy. The clothed nude is more obscene than the naked; the visible suggests the hidden. Her nudity might be veiled, but one was led to think about it, to visualize the conditions under which art was made, to reflect on the mores of bohemia and the wantonness of models, provoking feelings of shame and hatred.

With this sculpture, then, Degas transgressed twice over, breaking the rules of polite society and those of academic art. His taboo-breaking revolution was both moral and esthetic. On the one hand, he chose a scabrous subject that ran afoul of moral standards; on the other, he undermined the very foundations of statuary art. While Huysmans praised Degas as an artist who rejected "the study of classical art and the use of marble, stone, and bronze," thereby rescuing his work from a stultifying academicism, the guardians of the temple reviled Degas for "threatening the very identity of sculpture."[46] "It's barely a maquette," they said, and more like a piece of merchandise, something you could pick up in a bazaar. Degas was in fact well known for calling his works "wares" and "products." His open avoidance of elitism profoundly shocked the partisans of high art. The very conservative critic Anatole de Montaiglon, scandalized by the shop windows of the dressmaker Madame

Demarest, which were much talked about during the Universal Exposition of 1878, wrote with prescient irony: "These clothed mannequins in apparel shops are destined to become the latest fashion in art."[47] In the end, what was most disturbing was the inability to assign the *Little Dancer* to any fixed category. She was everything and its opposite: the model was a child, but she looked like a criminal; a ballet dancer, but inelegant — at once "refined and barbarous,"[48] wrote Huysmans, "an admixture of grace and working-class vileness."[49] Too large to be a toy, too small for a girl of fourteen, the *Little Dancer* hovered between the work of art and the everyday object, the statue and the mannequin, the doll, the miniature, the figurine. She advanced a tightrope walker's foot onto the wire stretched between the fine arts and popular culture, between poetry and prose; she was both classical and modern, realistic and subjective, esthetic and popular, common and beautiful. "This enigmatic little creature, who is at once sly and untainted,"[50] suggested different interpretations while not being reducible to any, and refused to be boxed in by anything but her glass cage. The cage itself resisted any simple explanation: ordinarily, in museums, glass cases are reserved for objects — or taxidermied animals, hence the word "cage," which was used by some (while others used the word "jar") who found it appropriate for this "animal." The fabric she stood on also excited speculation: the base of a statue normally has no such adornment, which is more commonly seen in commercial

displays. (It works fine for Cosette's doll, but for Degas's statue?) The satiny fabric also suggested Courbet's recent painting, *The Origin of the World*, in which a woman's genitals are displayed against a similar white cloth. The painting had not been exhibited publicly, but a few insiders, Degas among them, were likely to have seen it. For those in the know, the obscene association would have seemed obvious and deliberate. On the other hand, Degas, though in the prime of life, already lived as a quasi-hermit, a recluse in his studio. His reputation was unblemished by any scandal, unlike Courbet's, and no whisper of depravity attached to him. By putting a transparent obstacle between his statue and the public, by preventing his dancer from being touched, might not Degas have been displaying a haughty modesty, preserving the work's value, its rarity, and even its sacred dimension? One hardly knows what to think.

Even those who defended the work and saw in it "the first formulation of a new art," in Nina de Villard's words,[51] were unsettled as to its classification. The *Little Dancer* might well be called "the first Impressionist sculpture," but did it not reflect instead an extreme form of realism?

Degas is lumped in with the Impressionists, but it is only because he took part in the secessionist movement of the early 1860s that defined a group in opposition to the reigning academicists. Unable to exhibit in the official salons, a number of artists, including Renoir, Monet, and Manet, took over a parallel exhibition hall

known as the Salon des Refusés. But this salon, which only lasted a few years, was subject to violent attacks. Edgar Degas then joined with Claude Monet, Auguste Renoir, Paul Cézanne, Berthe Morisot, Alfred Sisley, and Camille Pissarro, all of them tired of the hostility of the official authorities, to form an association dedicated to mounting their own exhibitions. In December 1873, they adopted the generic name *Société anonyme des artistes peintres, sculpteurs et graveurs*, but were ironically rechristened the "Impressionists" by a critic who singled out Monet's canvas *Impression, Sunrise*. The Impressionists: the name would stick, to the great displeasure of Edgar Degas, who had proposed the name "Intransigents" and considered himself part of a "realist movement." This separation from the others explains much about Degas. The critics were well aware of it. "Proximity is not kinship," they noted, and although Degas exhibited alongside Pissarro, Sisley, and Monet, "he was an alien in their midst."[52] His friend Jacques-Émile Blanche underlined the fact in his recollections: "Monsieur Degas was called an 'Impressionist' because he belonged to the group of painters Monet christened with that name; but Monsieur Degas was among them as an outsider. He painted emphatically, instead of 'suggesting' by rough signs, or equivalents, as those landscapists did who, not yet daring to call their sketches 'paintings,' classified them as 'impressions.'"[53]

He painted emphatically, instead of suggesting. He didn't seduce, he frightened. It's worth bringing these two phrases

of Jacques-Émile Blanche's together. They express the essence of Degas's work, at least during those years: he emphasized and he frightened. He emphasized in order to frighten. He "impressed" but in a different way than his painter friends. Huysmans, following Blanche's lead, contrasted him to Gustave Moreau, whose work, he wrote, lay "outside any particular time, flying into the beyond, soaring in dreams, far from the excremental ideas secreted by a whole nation." Degas, on the contrary, belonged to that family of painters "whose mind is far from nomadic, whose stay-at-home imagination cleaves to the actual period," and whose work is entirely taken up with "this environment that they hate, this environment whose blemishes and shames they scrutinize and express."[54] It is the eternal battle in the arts between those who live in their imaginations and those who are fiercely committed to reality. Huysmans not only placed Degas in the latter group but named him one of its most personal masters, "the most piercing of them all," who, by his "attentive cruelty," gave "so precise a sensation of the strange, so accurate a rendition of the unseen, that one wonders at being surprised by it."[55] Degas, though he admired the work of Gustave Moreau, could be cuttingly sarcastic about the imaginary accessories in his paintings: "He wants us to believe that the gods wore watch chains."[56] But though he drew a line between himself and artists such as Moreau, who took their inspiration from mythology and the ideal, he was not to be confused with the Impressionist school then

coming into its own. It was true that the Impressionists, like Degas, had broken away from historical, mythological, and religious subjects, from the pomp of their predecessors. Renoir, for example, described his relief at escaping the sculpture hall of the Luxembourg Museum and "those terrified and too-white statues,"[57] diametric opposites of the *Little Dancer*. Degas also shared the Impressionists' love of contemporary scenes and their taste for technical inventiveness and creative freedom. But unlike them, he hated to work outdoors and was passionately attached to drawing, and therefore to the outline. More significantly, he looked at the world with less forgiving eyes, and his vision was orders of magnitude less lighthearted. While Claude Monet and Camille Pissarro expressed their wonderment at nature and its vision-blurring tricks of light, while Mary Cassatt, Auguste Renoir, and Berthe Morisot presented charming scenes of middle-class and family life, with women and children shown in all their beauty, Edgar Degas captured an unfiltered reality and provoked disquieting sensations. He questioned society. In this sense, he was much more a realist than an Impressionist. His contemporaries, in fact, reproached him for pushing his realism to extremes. It was all well and good to tear down "the partition dividing the atelier from ordinary life,"[58] but he went too far in applying "the major rule of naturalism," which was to exaggerate physical and moral ugliness. Even his friends deplored his tendency always to "search within the real for the defective grain."[59]

Just taking representations of childhood, we won't find much in common between the *Little Dancer Aged Fourteen* and Berthe Morisot's *Eugène Manet and His Daughter in the Garden at Bougival*, painted the same year, or Renoir's *Child with a Bird*, both of which feature lovely little girls who are happy and protected. On this score, critics spoke of the Impressionists' "social blindness," which divided them from Degas. Despite his reputation as a haughty bourgeois, Degas has more in common here with such predecessors as Millet, who was attentive to rural poverty, and to contemporaries now somewhat fallen from favor, such as Fernand Pelez, a painter of street urchins.

It is therefore difficult to accept the *Little Dancer*'s title to being "the first Impressionist statue," given that the sculpture's very technique, its three-dimensionality, and its accessories further accentuated its realism. It is also a work whose fragile material provided an analogue for the state of contemporary society, a society that came into being at a time when literature was dominated by an exceedingly harsh strain of naturalism. We should remember, however, that Émile Zola, though the leader of this school of writing, rejected what he called "photographic realism" in painting. In 1878, he criticized Gustave Caillebotte's *The Floor Scrapers* for being "bourgeois by reason of its exactitude,"[60] though he would soften toward the painter in subsequent years and praise him for his "courage" as a truth teller. What made the difference between a flat, dutiful verisimilitude and

inspired realism was obviously talent — Degas's palette, for instance, with its greens, blues, and pinks, was far removed from nature. Degas was certainly looking for reality, but "what he asked of reality was the new."[61] For him, as for Delacroix before him, "everything was a subject," there were no marginal or vulgar motifs. Chafing at the label of "Impressionist," Degas would have preferred to be identified as an "Intransigent." And we can see why: he doesn't compromise with the truth. Stripped of any effect that might embellish reality, his sculpture clashed with bourgeois taste, just as the novels of Zola and Maupassant did, disappointing the imagination and offering an art "pruned of all fancy," which no doubt had its place, according to the critic Paul Mantz, "in the history of cruel arts."[62] Unlike most of the Impressionists, he didn't emphasize the sort of classic beauty presented in ideal form by earlier masters. In the words of art critic Joseph Czapski, "Degas *discovered* another beauty in the reality around him...a totally new and tragic beauty."[63] Going further, Czapski attributes to Degas "the discovery of *ugliness*, which the painter changes into artistic beauty, the discovery of baseness and brutality, which, *transposed*, becomes a perfect work of art."[64] If Degas broke the harmony that pervaded the art of his admired predecessors, it was to express, Czapski continues, "the moral tragedy of the period...the material and spiritual upheavals of his time, and that was his greatness." But, he concludes, "morally, philosophically, religiously, it represented a collapse of something, a tragedy."[65]

MARIE VAN GOETHEM was an instance of this tragedy, its witness, its model, its fetish, its symbol. Degas's masterpiece, in its modernity, may mark a break with the esthetic past, but the "collapse of something" also corresponds to someone's lived reality: Marie was there, she is in the work. That's why the story of the *Little Dancer Aged Fourteen* can't end here. What is still missing, what I have not found—I who seek to know everything about her—is something that is neither moral nor philosophic nor religious, or rather something that is all those things together. Beyond the physical, and beyond the critical reviews, what is missing is her soul. Degas's ghost instantly takes issue, the painter having always objected strenuously to talk of the soul and "the influence of the soul." "We speak a less pretentious language," he said, claiming to be subject only to "the influence of the eyes."[66] The word "soul" may be in disuse, permeated with religion—and the thing itself may be unlocatable—but it pertains to all works of art, beyond what the senses perceive. The sculpture cannot simply embody a period, a state of society, an esthetic, nor even a modernist or avant-garde movement. What makes it a universal work of art is precisely what evades all these meanings, however strong or essential they may be, what transcends them. And at the other end of the equation, it is what each person may find there for herself, outside of time, in attunement with her own personal narrative.

Huysmans described Degas's brand of realism as "an art expressing an expansive or abridged upwelling of soul, within living bodies, in perfect accord with their surroundings." Zola, for his part, wrote that the work of art is "a corner of creation viewed through a particular temperament."[67] Marie van Goethem was that corner of creation—a modest fragment, neither particularly visible nor particularly attractive—and Degas was that temperament—visual, tactile, and very solitary. What were they doing together? Why were they both there? What "upwelling of soul" or what spirit was born of this couple? By what mystery, by what detours, by what desires? What was happening in these living bodies, whose encounter would give birth to a work of art and give rise to an extended future existence for themselves?

2

Do we know what we touch? Do we know what it's made of?
It is a mystery.

—*Edgar Degas*

A woman, which is to say a question, a pure enigma.

—*Julien Gracq*

EDGAR DEGAS AND MARIE VAN GOETHEM. One was born in 1834, the other in 1865. Both are in the studio, rue Fontaine, two living bodies, separated by thirty-one years and a world of circumstances. He has no children, she is of an age to be his daughter. He chose her because she is fourteen years old and looks to be only twelve, because she is neither very pretty nor very refined, because she has that slight look of insolence you often find in girls who have no other weapon against the world or their mothers. Did he find in her "that touch of ugliness without which there is no salvation," as he would write to Henri Rouart about the lovely women of New Orleans?[1] Did he like the ordinariness of her figure, because, to his way

of thinking, "grace is in the ordinary"?[2] Or was she, as it is believed, more charming than he represented her, with a less primitive face? After all, Degas had a reputation for painting without embellishing, even to the point of uglifying, especially in his depictions of women. When, in 1866, Manet saw the unbecoming portrait that Degas had painted of his wife, he was so furious that he cut out the offending section of the canvas. Degas had no interest in the clichés of feminine beauty. He did sometimes hire other kinds of models, young women of greater elegance and with more experience at the unrewarding job of posing for painters. One such was the famous Ellen Andrée, also a favorite model of Renoir and Manet; another was Eugénie Fiocre, a ballerina at the Paris Opera. But neither corresponded to his mental image at the time he turned to making his small wax statue, around 1879. He wanted this little rat, whose poverty he knew, and in whom he recognized, as he wrote in a poem, "the race of the street."[3]

LET'S IMAGINE THE SCENE. On the first day she posed, Degas had to accept the presence of Marie's mother in the studio. The woman was no doubt eager to learn what advantage could be gained from her daughter's new employment, and she was also anxious to preserve appearances. At the Paris Opera, as in the studio, the mothers pretended to supervise the fresh-faced recruits, all the while assessing the men. Degas had a

different reputation than Renoir or Corot, who considered that a painting was finished when they felt the urge to sleep with their model. In his mid-forties and of a serious, almost haughty demeanor, he was not known to make gallant assaults on women. Besides, Marie's elder sister had posed for him earlier and come to no harm...but she'd received no windfall either. He himself had lost his mother at the age of thirteen, was unmarried, and lived alone with his housekeeper, Sabine Neyt, who would die in 1882 and be immediately replaced by Zoé Closier, another faithful servant. His only company, then, was a woman who prepared his meals, kept house for him, and read him the newspaper. But Madame van Goethem insisted on attending the modeling session. Still water runs deep and dirty, as she knew well enough! Who could say what ideas might enter his head? But Degas refused. He didn't want some old hen prattling away while he worked, destroying his concentration. He needed to be alone with his model. In the end, Marie's mother agreed to stay in the pantry with the housekeeper. The main thing was to negotiate the best salary possible, higher than at the Paris Opera. And before long, she stopped accompanying her daughter.

Did Degas talk to Marie during the first modeling session? Did he explain his project to her? He had a reputation for brilliance and for voicing profound thoughts, and also for being an extraordinary conversationalist, fond of puns and jovial banter. But for him,

"the Muses worked all day. At night ... they danced, they didn't speak."⁴ Besides, why would he waste his gift for subtle conversation on this little girl, who "came from the oven half-baked"⁵ and was practically illiterate. His talk utterly charmed the poet Stéphane Mallarmé and prompted Paul Valéry to write reams of praise, but how much importance would he attach to conversing with this unpolished little rat? Degas, in any case, seemed to harbor an intellectual distrust toward women that closely bordered on contempt. Commenting on his *Visit to a Museum*, which was painted around the same time, Degas said he wanted "to give an idea of the boredom, despondency ... and total absence of sensation that women experience in front of paintings." It seems that Degas shared the misogyny that was rampant at the end of the nineteenth century, and which is visible in the writings of the Goncourt brothers and J.-K. Huysmans. In a collection called *Certains*, Huysmans wrote ironically about "ladies who, as everyone knows, take a lively interest in painting, which they understand almost as well as they understand literature — and that's saying something."⁶ Similarly, Degas attributed no esthetic sense to well-born women, or even any emotion, but it is hard to see him holding forth in this vein and expounding his "calculations on art"⁷ to Marie. More likely, he told her in a gruff voice what he expected of her. She was, after all, his employee at four francs a day. It was up to her to prove that she had more native intelligence than he thought, or at least some readiness at repartee, which

would not be unusual in a child of the Paris streets. At least they would sometimes laugh together.

Once he'd asked her to put on her dance costume, he didn't hesitate long over the pose. He'd already envisioned it, having seen it at the theater. He already had its outline in his mind, where "imagination collaborates with memory."[8] He didn't make her perform an arabesque or an entrechat, some complicated choreographic movement — besides, she couldn't hold the pose for long if he did. The pose imprinted in his brain derived more from childhood games than from dance, and it had been in his mind for almost twenty years. In the foreground of *Young Spartans*, a canvas dated 1860 — Marie was not yet born — the female character, whose inspiration derived from Degas's reading of Plutarch, already makes that same slight backward movement, as though, still immature, she were hesitating between contradictory feelings about the boys in front of her. This youthful painting, to which Degas himself gave the full title *Young Spartan Girls Challenging the Boys*, offers a metaphor for the relation between the sexes. It was a canvas that the painter held in particular affection, since he placed it on an easel in his studio, where it greeted visitors for many years. According to Daniel Halévy, this was also the work that was with him at the end, in the room where he died, raising the possibility that this contrapposto was the last image he saw. Did this posture capture for Degas a kind of essence of developing womanhood, an in-between state that he himself perhaps knew, halfway

between advancing and drawing back, attraction and refusal, an intimate paradox? At all events, one finds it in several of his works over the years with slight variations, and it is this figure that in our eyes stands as Edgar Degas's secret signature, his *cosa mentale*, the material projection of his thought.

Degas demonstrated for his model how she was to pose; he mimed the gesture. "It was really very amusing to see him, raised up *en pointe*, his arms rounded, melding the esthetic of a ballet master with the esthetic of a painter," wrote Edmond de Goncourt in his *Journal*.[9] Then he corrected the pose on the model herself. He touched her arms to bring them behind her, and after that her right leg, in order to create an oblique line, and raised her chin to the desired angle. Marie would not only have to hold the pose but also remember it exactly, so as to re-create it in future sessions. Degas would dwell on this point: modeling is serious work, we are not here to pick daisies. Often, he would upbraid her: "You're slumping, stand up straight!" or "longer in the neck," or "the arms more extended," and she would correct her position, just as at rehearsals. She wouldn't have complained, the pose was one of rest—yet not entirely, as her arms thrust out behind her were not in a natural position. She would have preferred putting her hands on her hips, but it also could have been worse. She held her fourth position steadily. Degas could have worked from a photograph, as many artists already did. Delacroix, his idol, had recommended the technique to painters from

the very earliest days of photography, as a way to avoid having to pay a model. But it was different for a sculptor. Degas needed Marie to be there, and he needed her to return. When he had adjusted the pose, he sketched her from every angle, highlighting his drawings in chalk and sketching in pastels on colored paper — a material that today has gone somewhat brown. It is moving to recognize the ribbon in the girl's hair and, at the top of the sheet, her name, uncertainly spelled, in Degas's hand: "Marie Vangutten," and her address, "36 rue de Douai." This intrusion of the real is troubling, it gives us access to a moment of pure presence: we are in the studio, and Degas is jotting down his little model's contact information for fear of forgetting it. This is the beginning of their adventure together.

The many preparatory sketches indicate the technical difficulties the sculptor faced. He made twenty-six studies for the *Little Dancer*, both naked and clothed, from twenty or so different vantage points. He had difficulty, for instance, rendering Marie's left foot from behind and started over several times; it shouldn't look deformed. And how was one to make the curve of her arms look natural from every viewing angle? He also completed many close-up drawings of Marie's face. In *Four Studies of a Dancer*, we see her in frontal view, a pretty, dark-haired girl with round cheeks, wide-open eyes, and a searching gaze. This is no doubt as close as we will get to her actual appearance, whereas the other drawings make her features seem coarser.

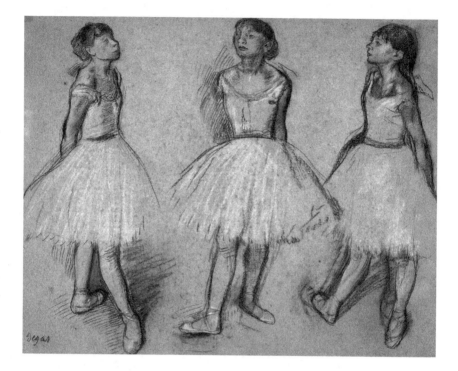

Why did Degas decide to sculpt rather than paint his model? His "bad eyes" were the reason he often gave at the start of the process. If "vision is palpation by the sense of sight,"[10] he was now obliged to privilege his other senses. "I feel the need, now more than ever, to translate my impressions of form into sculpture," he wrote the art critic François Thiébault-Sisson.[11] His eyesight having deteriorated, he received "impressions of form" rather than a sharp vision of the outlines—in that sense, the term "Impressionist" may in the end apply to him. But other motivations were at play as well. Drawing a dancer, he wrote, was "to create a momentary illusion," but yielded only "a figure without thickness, with no sense of mass or volume, something inaccurate." Accuracy was a major concern, and truth an even greater. "Truth is something you only obtain by sculpting, because the technique places constraints on the artist, forcing him to overlook nothing essential."[12] The choice of sculpture was therefore not motivated, as is sometimes believed, by the desire "to relieve himself of the strain of painting and drawing" by resting his eyes. It was a constraint consciously assumed to obtain "more expression, more ardor, and more life" in his work as a painter. The experience of sculpture, the sensations it provided, were meant to bring greater truth to his pictorial practice and allow him to grasp something that drawing alone could not access. In his interview with Thiébault-Sisson, Degas even used the surprising term "documents." If he "made wax figures of animals and

people," it was not, he claimed, in order to sell or even show the works: "These are exercises to get me going; documents, nothing more." A little further on, he would use the word "experiment": "No one will ever see these experiments... By the time I die, all of this will have disintegrated on its own, and so much the better for my reputation."[3]

These words, spoken in 1897, are a little disappointing. Was the *Little Dancer* no more than a "document"? Was Degas somehow ashamed of this portion of his work, believing it of no importance and on the order of a sketch? Degas's studio was littered with bits of wax, because he was always starting over with his "experiments" and was never happy with the result, as though completion were neither expected nor aimed at. Yet is there not in his depreciation of his wax sculptures an element of denial, of false modesty, of coyness? If he was telling the truth, why did he exhibit his *Little Dancer* in 1881? Why were 150 other statuettes found among his effects, in poor repair admittedly, but neither thrown away nor destroyed?

It's likely that the scandal and poor reception that greeted the *Little Dancer* are what caused Degas, who became very cantankerous at the end of his life, to downplay his wax sculptures and claim to have made them "for [his] sole satisfaction" and not for public view, unlike his monotypes and paintings. But at least when it comes to the *Little Dancer*, the preparatory studies suggest the opposite progression: it's the drawings that

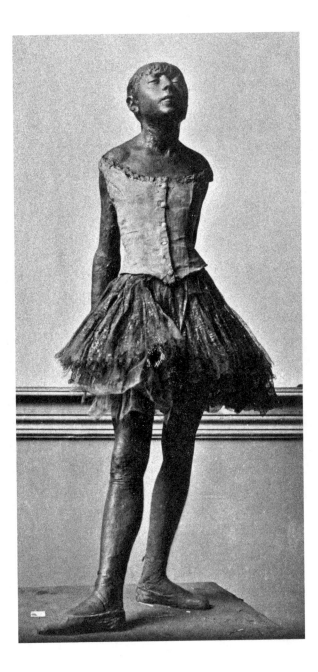

appear to be "experiments," with their corrections, redrawings, and erasures. And it's the pastels that "document" the future statue. Let's not forget that while Degas studied painting with masters, starting in his youth, he was a complete autodidact in sculpture. In fact, thinking about the two arts, he seems to contrast surface and depth, the skin and the flesh. He asserts loud and clear that the surface, even when it seems the subject of his canvas, does not interest him, that his art does not consist of "caressing a torso's epidermis": "As for the frisson of skin, poppycock!" said Degas. "What matters to me is to express nature in all its aspects, movement in its exact truth, to accentuate bone and muscle, and the compact firmness of flesh."[14] What the hand grazes over in painting, it grasps in sculpture. The reality of living flesh came through as a result of kneading the flesh. "The most beautiful drawing," said Degas, "the most carefully studied, falls short of full and absolute truth, and thus opens the door to sham." He came close to "the full truth" thanks to modeling, "because approximation has no place there." It is drawing, therefore, that prepares the way toward truth. Next, the hands touch the body, then they sculpt the wax, and that in turn touches the soul.

So it was that after completing various sketches of Marie in a tutu, Degas asked her to remove her clothes. She had to be naked. Only then would he be able to capture the body's movement, its tensions, its density. Behind the screen provided for that purpose, Marie

disrobed, setting her clothes down wherever she could. The studio was dusty and cluttered—Sabine was not allowed to clean there. Was Marie worldly-wise, as it is easy to imagine—a little rat tossed early into the scrum and used to hearing "words without a fig leaf"?[15] Or was she sweet and submissive, used to obeying? Going by the sculpture, we might incline toward the first hypothesis, while the drawings of her face suggest the second. Was she embarrassed to stand naked before this stern man, alone with him in a jumble of easels, frames, armatures, tools, spirits, ballet slippers, powders, flasks and boxes, and cupboards filled with artworks? In fin-de-siècle Paris, relatively few models were willing to pose in the nude. The little rat of the Paris Opera was a profoundly paradoxical being, and that is why Degas chose to portray her. She lived three-quarters of the time in an artificial world where dance and lyric song expressed great tragedies against the backdrop of magnificent scenery, which was lifted on and off the stage by complicated and costly machinery. She displayed herself, both onstage and in the wings, for the pleasure of an elegant and libertine public, constantly aware of the huge disparities of the social order. During the performances where the rat had a walk-on role, she wore and admired costumes that inspired her to dream, and she used her body to interpret universal feelings. But she barely knew how to read, often had to remain silent or "speak only with her feet," and afterward she went home to her hovel. Pulled between a make-believe world and a harsh reality,

between opulence and insecurity, glitz and grime, the little rat, who was "as corrupt as an old diplomat and as naive as a savage,"[16] embodied the tension that Degas sought to re-create under his fingers.

The model's age produced another sort of tension or uncertainty, between the child and the woman, innocence and sensuality, that fascinated the artist. Without her clothes, Marie, as we see her in the nude studies Degas made in wax and charcoal, seems very young. With her large feet and flat chest, she looks undeveloped. Naked, the young model displays a visible kind of innocence, but Degas had to find a way of expressing all her ambiguity, of representing this urchin who was knowing about "vice but not life."[17] At fourteen, did Marie not have a natural modesty that made her more fragile? Or was she already used to the male gaze and the promiscuous display of her body? Perhaps she had already posed for other painters, more licentious ones. Or perhaps she was simply relieved to be performing work that was better paid and less tiring than training for the ballet, even if it meant holding a pose for hours. Antoinette, her older sister, must have told Marie about the endless sessions—as if Degas had no inkling of the pain his models endured. This was certainly true, for when he developed an interest in photography a few years later, he put his friends through agonies, making them pose for hours at a time, a practice they all complained about. Antoinette may also have warned Marie that the painter was bad-tempered, that he was

never happy, that he could humiliate. But for Marie, this bearded man in a gray smock and cap, however unpleasant, was still less harsh than her ballet masters.

Degas approached Marie. He made a tight circle around her. "My nose close to my model, I examine her," he said. The object for him was "to sum up [the model] in a small piece, but one whose structure is solid and doesn't lie."[18] The imperative was always to arrive at truth. Solidity and firmness were correlates. Despite what one might imagine about ballet, Degas was more interested in earth than in air. Marie, like the eventual sculpture, was firmly planted on both feet, which were placed in rulebook position; her balance came from being anchored to the ground. Her small and lanky but well-muscled body resembled the bodies of our dancers today, giving her a "modern look, very Parisian and honed."[19] In order to measure and compare the different parts of the body correctly, Degas used a special instrument, a proportional divider, which frightened the models when he brought the point too close to their faces, sometimes gashing them. The jottings in his notebooks have the look of surrealist poems: "the hands are 9 noses,...the arm from shoulder to wrist is 2 heads,..."[20] His measurements then had to be reduced to the scale he had chosen, which was less than life-sized. Yet respecting proportions was not his top priority. Without going as far as Ingres, his master, who blithely disregarded human proportions, once adding three vertebrae to an odalisque's back, Degas took

occasional liberties with anatomical reality. "The arms are too long, and this from the man who, yardstick in hand, measures proportions so meticulously," joked Gauguin.[21] In this case, it's the *Little Dancer's* right leg that seems abnormally long, intentionally accentuating the sense of relaxed stretching. Although Degas did not make his sculpture life-sized, he could have done so, as Marie was less than five feet tall, but a recent scandal had rocked the art world. In 1877, Rodin was criticized for using molds taken directly from his models to make *The Age of Bronze* and other statues. Mold making was widely used in the nineteenth century by various scientific disciplines to preserve an object's impression, but it was felt to detract from the artistic value of sculpture. The artist was meant to "represent" reality, not replicate it or trace it directly from nature. As Renoir put it crudely, a work shouldn't "stink of the model."[22] That's what made the difference between art and mere skill or technical expertise. Taking a direct mold from nature should be kept for anatomical models, which the sculptor might use for inspiration but nothing more. To ward off this line of criticism and avoid polemics, Degas altered the scale of his works. All his sculptures are less than life-sized.

Yet sculpture would seem to be an art that is inseparable from technique. In practice, after drawing a great number of preparatory sketches, what did Degas do in the midst of his studio while Marie struggled to maintain her pose? He sat on a kind of saddle, from which

he often arose to approach his model. He touched her, traced the lines of her body, probed its density, poked at her joints, studied the insertion of the muscles. If we are to believe Gauguin, who visited Degas at work, the sculptor looked for the true in "the human carcass, the skeletal frame, its articulated movement."[3]

From this coming and going, a wire skeleton would gradually take shape, roughly corresponding to the intended figure. Its different parts—the torso, legs, etc.—would be attached with cable or string to metal plates. In a moving letter to Henri Rouart, Degas wrote: "Do you remember one day, you were saying about someone that *he no longer assembled*, a term used in medicine for defective minds. I've always remembered it. My eyesight no longer assembles, or does so with such difficulty that I'm often tempted to give up and sleep, never to wake."[4] Perhaps this composite mannequin allowed the artist to avert his anguish.

A statuette of the naked Marie, three-quarters the size of the final work, shows that Degas made maquettes to start with, trying things, making corrections, improving this position, this proportion, and also experimenting with more or less elaborate technical solutions. Recent x-rays of the finished sculpture show it to be chock-full of random objects, starting with paintbrush handles. There were also rags, wood shavings, cotton wadding, drinking glasses, and cork stoppers, all taken from Degas's immediate environment, a kind of haphazard improvisation in keeping with his model. His

realism in fact draws its power from the perfect appropriateness of treatment to subject. His art, at once poor in means and meticulous in execution, a brilliant makeshift improvisation, was adapted to Marie, a little girl who was living in poverty and without sophistication but who nonetheless tried to achieve purity of movement. By raising the lowly to the level of art, by using crude techniques and common materials, Degas opened up and freed a vast space for creation. His eclecticism was revolutionary. A whole tendency of the art of the twentieth century would arise from this little cobbled figure. The year of its making, 1881, was also the birth year of ... Picasso, for example.

Onto this metal armature, stuffed with whatever came within reach, Degas smeared by hand or with a spatula several layers of colored wax, whose smooth surface suggested skin, though without reproducing its natural color. It's the same wax that, variously pigmented, would also cover the human hair that Degas had bought at the wigmaker's, the specially tailored linen bodice, and the real ballet slippers, shaded a delicate pink. Only the tutu would be added intact to the finished sculpture. The beeswax, whose pellucid aspect catches the light, was mixed with clay and plasticine, which is a greasy, claylike substance that has the advantage of remaining soft for some time, allowing the sculptor to shape and reshape the material until it approached the ideal contour. This is why Degas refused to use more solid materials. "Have it cast? Bronze is for eternity. What gives me

pleasure is always having to start over."[25] And according to Renoir, the reason Degas did not exhibit the work in 1880 as planned was that he wanted to reshape the mouth, which did not satisfy him. X-rays have shown that he remodeled the head several times, lengthening the neck proportionately with a wire coiled like a spring, and repositioning the shoulders. He had a reputation for endlessly reworking his pieces, inspiring his friend J.-É. Blanche to comment: "The slightest pretext served him to torture the form, to extract from it a cruel synthesis that joined the observation of a misogynist and a surgeon."[26]

Is that the person Marie found across from her, an unappealing combination of the misogynist and the surgeon? Does the sculpture offer nothing more than the "cruel synthesis" of a clinical examination and sexist disgust? That's not what it makes us feel, however. Still, the relationship between Degas and his model remains a mystery. Pauline, one of his favorites, claimed to have danced naked with him in his studio—he liked having such rumors circulate. But his letters and contemporary testimony show that, while the painter may have enjoyed good relations with the dancers who posed for him, it never went beyond the stage of well-meaning paternalism. He sometimes interceded with the management of the Paris Opera to obtain a salary increase for one or a role in a ballet for another; it amused him, nothing more. Most likely he retained a natural sense of class—and gender—superiority. We will never know

what he thought of the First International Conference of Women's Rights, convened in Paris in 1878. He was often to be found at cafés: the Nouvelle Athènes, the Rat Mort, which was open all night, the Brasserie des Martyrs, where ballerinas and bohemians mingled, whose company he much preferred to the crowd around Zola. But his life sank into an ever greater solitude. "A sickly man, neurotic, suffering from ophthalmia," wrote Edmond de Goncourt. He is not known to have had any romantic attachments, whether long-term or short, a fact definitely out of keeping with his time and place. And when we consider how eagerly the Goncourt brothers seized on any sliver of gossip, the fact that there is none about Degas in their *Journal* is significant. Any number of nineteenth-century painters seduced or married their models, or made their wife their muse. Delacroix, one of Degas's masters, describes in his *Journal* the "valiant battles" he waged with lust during sessions with his model, battles that he lost more than once: "How lovely she was, naked and in bed!"[7] he wrote about one of his young sitters, a girl of fifteen. About another, he wrote more crudely: "I risked the pox for her." Corot squarely made sex a corollary of studio work. Puvis de Chavannes would punctuate his sessions with his paid model by saying, "Would you like to see the...of a great man?"[8] And Whistler, Monet, Rodin, Renoir, Bonnard, and so many other contemporaries of Degas also stepped over the line in their relationships with the young women who sat for them. The model

who is at once muse and mistress has been a common-place in art since the beginning.

Degas did not fit the stereotype. He was famously chaste. For the greater part of his life, his company at home consisted of two successive housekeepers, whose cooking and discretion he appreciated, period. He is not suspected of having taken any liberties. His celibacy has been attributed to his misogyny. His distrust of women stemmed, according to some sources, from contracting a venereal disease at a brothel in early youth. He made unflattering quips about women, and they were more provocative than those made by Corot, Renoir, and a good number of fin-de-siècle writers, who said such things as a matter of course. Renoir did not approve of educating the weaker sex, for instance, believing its effects might be terrible, namely "that future genera-tions would make love very poorly"![29] Was Degas afraid of women? It's possible, judging from the qualifiers he attached, though jokingly, to the women in his circle: "your terror-inspiring wife," "your formidable spouse," are phrases that appear often in his letters. Ambroise Vollard confirmed it: "A kind of shyness, mixed with an element of fear, kept him away from women."[30] Manet reported to Berthe Morisot the rumors circu-lating about the painter of dancers: "He is not capable of making love to a woman, either in speech or in act."[31] A woman friend defended "the artist without a muse": "Extreme oversensitivity was clearly the source of his exaggerated fear that a woman, by the power of her

love, might exert undue influence over his work."[32] He did at one point consider getting married and having children, but without much conviction. As he traveled to visit cousins in New Orleans in 1872, the idea crossed his mind: "I have a thirst for order. And I no longer look at women as the enemy of this new mode of being. Acquiring, even producing a few children, would that be too terrible? Not really."[33] He appears to have been motivated more by convention than by passion, however, and despite his fears of living a life of regret, he never brought himself to marry or cohabit. The reason must lie in his art. Degas put art making above all other forms of activity. It occupied his mind, his body, and his soul. All his desire, all his sensuality, were turned toward the work itself, and the model was only the work's pretext. "Is not work the only good we can possess whenever we like?"[34] he wrote in August 1882 to his friend Bartholomé. Paul Valéry distinguished between "finite passions," such as love, ambition, and desire for money, and the infinite, obsessive passion that drove Degas: the desire to create and progress ever further in his art. "Is an artist a man?" he asked rhetorically.[35] The answer he later gave was: "A painter has no private life."[36]

For him, art transcended all else and was "made of renunciations." This is what Vincent van Gogh grasped about him and, in crude terms, wrote to his friend Émile Bernard in August 1888: "Why do you say that de Gas can't get hard? De Gas lives like a little law clerk and doesn't like women, knowing that if he liked them

and fucked them often, he would become deranged and inept at painting. The painting of de Gas is virile and impersonal precisely because he has resigned himself to being nothing more than a little law clerk with a horror of riotous living. He looks at human animals stronger than himself getting hard and fucking, and he paints them well, for the very reason that he makes no great claims to getting hard-ons."Van Gogh continued: "If, for our part, we want to get a hard-on over our work, we must sometimes resign ourselves to fucking only a little...It's enough for our weak and impressionable artist brains to give their essence to creating paintings."[37]

Degas, if we are to believe Van Gogh and a fair number of his contemporaries, saw sex as nothing more than a threat to his art and women as "human animals," females of the species. When he painted them bathing, as he said himself, it was "as if beasts were cleaning themselves." With women of his own rank, he needed to diminish or even degrade them before he would paint them. He only agreed to paint the portrait of a quite beautiful woman friend if she would wear "an apron and a bonnet, like a maidservant."[38] There again, Renoir drove in the same nail: "Make a portrait of your concierge," he said. "Have you ever seen a society woman whose hands you would enjoy painting? Women's hands are lovely to paint, as long as they are hands that perform housework!"[39] Women had no intellectual side for Renoir, nor did painting. The female body had another meaning for him: "I couldn't work without a model. Even if I hardly

look at her, she is absolutely necessary to me to plump up my eyes. I love to paint a bosom, the folds of a stomach...A breast is round, it's warm!"[40] The model, he also said, is there "to arouse me." To arouse me, to plump up my eyes: we see the divide that separates him from Degas. The sensuality of Renoir, who spoke of "making love with his paintbrush," finds no echo in Degas, for whom the body was without spirit or emotion. For him, the body never became flesh, which is to say capable of opening itself up, making room for another, being welcoming. It's all no more than a false welcome — in brothels — or a veneer of beauty over a background of shabbiness — at the Paris Opera. Paul Gauguin admired the distance Degas maintained while giving himself entirely to his art: "Degas's dancers are not women. They are machines in motion, with gracious lines, prodigious for their balance."[41] But for a number of his contemporaries, Degas was above all a voyeur who liked "to look through the keyhole," a painter of dancers and brothel scenes because only vice interested and inspired him. His most famous metaphor supports this point of view: "Art is vice. You don't marry it lawfully, you rape it."[42] Despite this provocative stance, Renoir praised Degas for "his quasi-religious side, so chaste, which puts his work on such a high level" and which "grows greater still when he looks at young girls."[43] Even his most fervent admirers recognized in him a kind of two-headed Janus. Daniel Halévy, the son of his friend Ludovic, considered him "one of the classical giants of virtue," full

of greatness.[44] At the same time, he was shocked by Degas's seeming cruelty and condemned his intention in the *Little Dancer* to "humiliate the poor girl, a little monkey dressed in tulle and spangled in gold, making a mockery of her."[45] The ambiguity that attaches to Edgar Degas, "divided against himself,"[46] seems indissoluble. His mood swings were legendary, plunging him into the abyss: "I am sad, although lighthearted — or the reverse," he liked to say. Known for his love of paradox in conversation, he was himself paradoxical to his acquaintance. A declared misanthrope, a man who presented himself as hard and misogynistic, Degas offered a schoolgirl's image as a metaphor for his own deepest being: "I have locked away my heart in a pink satin slipper."[47]

IN THIS CONTEXT, what is to be made of the *Little Dancer*? What is Degas telling us about her? That she is prone to vice? To crime? Really? Only that? If he had wanted to show us her budding depravity, would he not have sexualized her more? At that time, of course, the image of a dancer in itself represented vice. But so young? He specified her age in the work's title, after all, though it was not usual. What meaning are we to assign to her half-closed eyes? Some have interpreted the girl's offered face as an invitation to sensuality, and the forward thrust of her hips as a sexual signal, unsettling, a provocation that makes the viewer uneasy. But are the almost closed eyes of the *Little Dancer* truly watching

the stranger who is about to grab her and kiss her on the lips? Are they not directed inward instead, oblivious to others? Do they not telegraph a kind of absence from the world? Unlike an artist such as Balthus, who, fifty years on, would make his passion for very young girls plain, Degas does not try to capture an erotic aura. When Balthus paints thirteen- or fourteen-year-old Lolitas in ankle socks with their underwear showing, their eyes closed, and stretching next to a cat, he means to capture, so he explains, the mystery inherent in adolescence at the dawn of womanhood and sexuality: "Adolescent girls stand for the future, before the transformation that will perfect their beauty. A woman has already found her place in the world, an adolescent has not. The body of a woman is already whole. The mystery is gone."[48] The sense we get from Degas's sculpture is similar to what Balthus describes, but the young girl's mystery is less overtly erotic, at least for today's spectators. And if Marie stood for the future in the eyes of contemporary viewers, it was a closed-off future, leading only to her isolation. Her mystery therefore comes closer to what Rilke has suggested about Balthus, whom he described as "the painter of young girls, who are offered to every desire, but in a closed world that sends them back to their own solitude."[49] If we replaced "young girls" in this sentence with "dancers," would this not aptly describe Degas's world, and more specifically his *Little Dancer Aged Fourteen*? "The painter of dancers" created few landscapes and outdoor scenes; most

of his subjects are found in performance halls, brothels, cafés — places where women, even when they are with others, even accompanied, are alone and with no opening to the world outside. Of course, the *Little Dancer*, being a sculpture, is freer in space than Degas's painted subjects. But let's not forget the glass cage that imprisoned her and the negative reception that greeted her when the sculpture was first shown. Is she not "offered to every desire," even the most unacceptable, but then dismissed "back to her own solitude"? Her nearly closed eyes suggest the way a person who is alone might plunge into herself to escape from suffering. With her veiled gaze, her inner emotions are hard to discern; her raised chin would indicate that she has no wish to communicate with anyone. Although alone, she accepts her solitude. Her impudence is not a come-on but a refusal of engagement. She asks for nothing. On the contrary, she prompts us to ask questions. What is she thinking about? What is her inner world like? Do her face and pose reflect concentration or relaxation? Boredom or pleasure? Is she taking herself elsewhere, and if so, to what foreign parts? Is she filled with a sense of her own self or does she savor the vacuum at her core? What lies behind her closed eyes, her skinny chest? Tears, dreams, unspeakable emotions? Or a kind of absence, a beneficent nothingness in suspended time? The sculpture provides no answer. Degas provides no answer. The work skirts around all answers, just as the model stays in balance between childhood and womanhood,

between innocence and lechery, between presence and elusiveness.

It's not by chance that Marilyn Monroe posed next to the *Little Dancer* in 1956. The black-and-white snapshot was taken after the filming of *Bus Stop*, at the house of producer William Goetz, a wealthy art collector. The actress was thirty years old and already a star, but her face in the photograph, which is right up close to the little rat's, has that pure, lost, searching look that her fans know well. This woman, the embodiment of childish femininity, but also of eroticism and sexuality, seems in perfect osmosis with the sculpted presence. Perhaps it is because, like Marie van Goethem, she was neglected by her mother as a child and is remembering the young Norma Jean Baker, an anonymous girl, who married at sixteen knowing nothing of the world. "You're not a scared, lonely little girl anymore," she wrote in 1955. "Remember, you sit on top of the world…it doesn't feel like it."[50] Around the same time, she had a nightmare: she dreamt that a surgeon cut open her stomach, and the only thing he found was "finely cut sawdust, like that of a Raggedy Ann doll."[51] How can one not think back to Degas's sculpture, its empty insides? Along with Goya, whom Monroe liked "for his monsters," Edgar Degas was one of the actress's favorite artists. And so, although she had never taken ballet lessons as a child like Audrey Hepburn and other Hollywood actresses, Marilyn had agreed two years earlier, in homage to the painter of dancers, to pose in a tutu for the famous series of

photographs by Milton Green. Her appearance in those photos has a moving fragility. The sex symbol has been replaced by a vulnerable young woman, clearly tired and distraught, a ballerina overcome by loneliness, a soul sister to the *Little Dancer.*

What would Degas have thought of these black-and-white photographs taken less than forty years after his death? What would he have said, this man who seemed to run from feminine beauty, about Marilyn passionately gazing at his most scandalous work or wearing a gauzy white tutu in a way that reminds us of his most famous canvases? Would he have seen in her, as we have seen in his model, both angel and beast, monster and child? The question hangs in the air, just as his relation with Marie van Goethem remains uncertain and, through her, his relationship to the other sex generally, to sex, and to the body. Daniel Halévy has reported that one of Degas's last gestures on his deathbed in 1917 was to grab, "with a strength no one suspected him to have," the naked arm of his young niece, who was plumping up his pillow, and to examine it fiercely in a shaft of daylight, as though to wrest its secret from it.[52]

Years earlier, drawing close to a girl on the cusp of womanhood, had Degas been trying to pierce the mystery of his own anxiety? Except for a few horses, he spent his life observing, painting, and sculpting women, presenting them in the most banal typology of seduction—as dancers, prostitutes, and naked models—all the while stripping these stereotypes of their attendant

attributes—beauty, grace, elegance, eroticism—to leave nothing but the weight of the real—tiredness, neglect, submission, and sometimes pleasure. Marie van Goethem carries the weight of this paradox on her slender shoulders. Mysteriously present yet preserving her distance, hovering between angel and beast, she fails to answer the question that Edgar Degas must have asked himself all his life: what is woman? "A woman, which is to say a question, a pure enigma."[53] All that survives of his quest is the impression of his fingers in the wax.

Or else—different hypothesis—or else this quest for the feminine, this unending investigation into the enigma of woman, into her essence behind conventional appearances, led him to considerations close to his home ground and hers, despite their differences in age, sex, and circumstance, a place that the two of them had in common—she, Marie van Goethem, and he, Edgar Degas. First, the ballerina and the artist both knew that hard work was needed to achieve a formal ideal. The little Opera rat endlessly rehearsed the same movements, while the sculptor made, unmade, and remade his ever imperfect maquettes. Another thing brought them together: their refusal to accept the judgment of others, the pride they took in showing insolence. Both pitted their solitude and desire for freedom against the world, one through his bitingly witty and ironic utterances, the other by her air of defiance and effrontery. Here again, Marilyn Monroe's words provide an echo: "Alone!!!! I am alone. I am always alone no matter

what. We should be afraid of nothing but fear. What do I believe in / What is truth / I believe in myself / even my most delicate / intangible feelings."[54] In the studio, Marie van Goethem and Edgar Degas shared a physical space that was also a symbolic locus, a bubble that subsumed even the work they performed together. This place that connects them is common to both art and life, to the art of life. In it, the couple creates a unique harmony, specific to them. Marie transmits its secret, Degas translates its mystery, their eyes shut, each in his or her own way. Their gaze — the blind man's and the young girl's — is internal, it creates its own *vision,* its universe, "a kind of infinity."[55] It allows one, while maintaining a degree of comportment (posture, form, syntax), to be infused with the animal grace of being alive, the joy of one's pure presence in the world. Depth and intensity subsist behind the smoothest surface. Tension animates the flesh without leading to action. The pose could be standing or lying down, hands clasped behind one's back or arms outstretched, nose in the air, eyelids lowered, whatever. It assumes a kind of happy passivity, "an inactivity of the mind, slowly allowing itself to be impregnated,"[56] a welcoming disposition, an abandon that promotes one's joy of living, creating, existing. It might be possible, desirable even, to imagine a little sunlight, as a letter from Degas to the Danish painter Lorenz Frölich invites us to do. In this letter, dated November 27, 1872, Degas explains artistic creation using an image from nature: "I'll tell you that in order to produce good

fruit, you need to espalier yourself. You stay that way all your days, your arms stretched out, your mouth open to absorb what's passing by, what's around you, in order to draw life from it."[57]

True, Marie didn't assume the shape of a tree in sunlight. But there's something of the espalier in her, as there is in him. Solidly anchored in earth, her head elsewhere, she is alive. Beyond the puzzle of childhood, of the feminine, the little dancer above all expresses what a dreamed, an imagined life might be, subtracted from the vagaries of time, the weight of loneliness, the penalty of being weak and powerless—a life at once rooted in the earth and turned toward the sky. It is Degas himself, therefore, identifying at midlife with the little dancer, who appears in this masterwork. You could describe it thus: the eyes are shut like a blind man's who sees with his whole being; the head is deaf to all criticism; the attitude has the insolence of someone who knows he is alone, someone concerned to capture the beauty of movement, while reveling in the sensation of being, a moment brimful of what is passing by. The *Little Dancer Aged Fourteen* is him. Nothing seeps out, all is shut down and held tight, but it was certainly within a faded pink slipper that he locked his heart away—locked it away, perhaps, but while still beating time to the world. Like Marie, he doesn't care what others say, and he despises critics, even the well-meaning ones, because to him creation is pure mystery. He doesn't care about academicism, about pretending, about alarmed refusals. All that

counts is art and one's way of existing, of being there. Here they are then, the two of them together in this "upwelling of soul," he and she like opened buds, the artist and the model, joined to a fugitive reality by the same desire, the wish to lead an espaliered life.

3

The means are as much a part of the truth as the result.
The search for truth must itself be true;
true research is the truth unpacked,
whose scattered elements are reunited in the result.

—*Karl Marx*

IT IS THE END OF NOVEMBER 2016. With the intention of coming to a close, I have reread all that I have written so far and reviewed my documentation as well, in order to establish an accurate bibliography. In the past two years, I have read many books—biographies of Degas, his notebooks, his letters, but also doctoral theses and articles on the history of art and dance. And I've read several novels, in French and in English, that have set out to tell, or rather to imagine, the life of the little dancer, aged fourteen. One of them, *The Painted Girls*, was a best seller in the United States, where the original sculpture now resides. Its author, the Canadian novelist Cathy Marie Buchanan, explained in an interview that her story was based on numerous studies but was fully three-quarters

fiction, due to the scarcity of documents. Another novelist, Carolyn Meyer, author of *Marie, Dancing,* invents a married life for the little rat, at a point long after all trace of her has been lost. The movies about her fall into the same vein. On the poster for a successful television film, *Degas and the Dancer,* by the Canadian director David Devine, is the tagline: "Encouraged by the great artist Edgar Degas, a young ballerina learns to have confidence in herself." I was troubled reading these fictional accounts, whose charm escaped me, and I disliked the films for their simplistic plots. My irritation was triggered by the utter nonsense and the minor gaffes alike, but primarily by seeing Marie's life presented otherwise than as my own research had led me to imagine it. The only image I found extraordinarily moving was the movie footage of Edgar Degas, filmed unawares by Sacha Guitry, as he walked along a busy Paris street, leaning on a cane. The writer and filmmaker Guitry comments solemnly in voice-over: "At the age of eighty, he is poor, ill-tempered, almost blind. But he is a genius." This is the only extant film footage of the artist. I would give a great deal to spend a similar few seconds in Marie van Goethem's company. To see her, even at an older age, even in profile, or from behind, or hidden under a hat! Adjusting the shoulder strap of her bodice, say, or massaging her calves! To have even a photograph. I need the reality, it is the basis of my desire. While I recognize that I too have more than once let my imagination take flight, at least I have tried not to stray from the direction of the truth,

particularly with respect to a work "forcibly residing in reality."[1] I like to have, as François Truffaut said, "verification through life." On this point at least, it was clear to me from the beginning that my project would take the form of nonfiction, also that I planned not to separate the model from the artist, that I would capture if possible some element of their relationship, out of which one of the great works of modern times arose. My affinities with the work are obviously subjective, and many other fans, both before and after me, have expressed or will express their fascination with this sculpture, just as many artists have created new work to convey its emotional or esthetic effect on them.

Misty Copeland, the first African American ballerina to have been named a principal dancer at the American Ballet Theater — in June 2015, after a journey full of twists and turns — decided to put on the stage the main poses of the ballerinas in Degas's paintings. It is striking to see her re-create perfectly in three dimensions the stance of the *Little Dancer Aged Fourteen,* whose body type she shares. Like Marie van Goethem, Misty Copeland comes from a large, impoverished family. Raised by her mother, she lived on social welfare before entering dance school and finding her way, despite the fierce opposition of the gatekeepers, who considered her skin color a barrier to a major career in ballet. When she assumes the pose of Degas's young model, she does more than simply call to mind the *Little Dancer.* She also evokes the tragedy of black slaves, whose image was displayed at colonial

exhibitions in the form of wax mannequins. Her reenactment of Degas's sculpture takes on universal import as a denunciation, through her own story and that of the little dancer, of all the obstacles that must be surmounted to avoid exclusion. And success is not granted to all.

Degas may have signed on — sometimes ambiguously — to the more progressive causes of his time, but other artists have since extended, deepened, or subverted his visionary work. This is the case, for instance, with Damien Hirst. This British visual artist, who has often exhibited real objects and animals in glass cases, has also created two monumental sculptures that reproduce the posture of Degas's *Little Dancer* in a very recognizable way. One of them, *The Virgin Mother,* shows a naked young girl, her feet in fourth position, her face tilted upward, one hand behind her back and the other on her pregnant stomach. The statue is divided in two longitudinally. On one side, the smooth bronze offers a troubling resemblance to Degas's work; on the other, bright reds and oranges simulate the cutaway view of a medical illustration: we see an anatomical rendering of the naked skull, the eye in its orbit, the flayed muscles of the arm, torso, and thigh, the mammary glands, as well as the fetus head-down in its mother's uterus. As small as Degas's sculpture is, Damien Hirst's is enormous. This giantess who is missing half her skin, is she intended to revive in the public mind the accusations of monstrosity raised against the original? Or recall the wax anatomical models that the *Little Dancer* was compared to at the

1881 exhibition? By calling his sculpture *The Virgin Mother*, Damien Hirst also makes glancing references to the Virgin Mary and to Mlle van Goethem's Christian name. All these allusions reopen the semifantastical questions raised by Degas's work and its model, both of them a mix of the trivial and the sacred, the virginal and the monstrous. And every viewer — or is it just me? — has to struggle deep down with her obsessions, in which the lost innocence of childhood and the sacred horror of life inside a human body play their part. Another of Damien Hirst's sculptures, *Verity,* reprises the same pregnant figure, half in cutaway, but holding a sword in one hand, and in the other, behind her back, carrying a scale. It is "an allegory of truth and justice." Is it not ironic, I ask myself, to represent these eternal figures from the art of the classical world in the form of cadavers undergoing dissection? Neither truth nor justice for the little dancer. A body slated to disappear. Death, and only death.

Looking, not without revulsion, at Damien Hirst's work, I find myself thinking that this is where things go wrong. Because I can feel that things go wrong here. This is neither truth nor justice. It's not right to make an allegory of her. Not right to disembody her, not right to flay her, I tell myself. Something is missing — something that passes through reality but transcends it, this is how I feel the question, sharply and confusedly. A sentence of Roland Barthes's pops into my head: "What writing demands...is the sacrifice of *a little* of the writer's Imaginary, and to assure thereby, through his language,

the assumption of a little reality."[2] This is what's missing: a little reality. A residue that no history can erode, a thing that does not cease to not be written. I reread Paul Valéry's description of Degas's studio: "The room was pell-mell — with a basin, a dull zinc tub, stale bathrobes, a danseuse modeled in wax with a real gauze tutu, in a glass cage, and easels loaded with charcoal sketches of snub-nosed, twisted models, with combs in their fists, held around a thick length of hair gripped tight in the other hand."[3] The statue presided over the room, just as it occupies the center of Valéry's sentence, imperial and humble at the same time. The *Little Dancer* seems to draw toward itself and swallow up all reality, until it feels that there is and can be no reality, in this text that claims to offer an account of it. No narrative encompasses reality. More even than in the bronze casts, reality inheres in the wax sculpture whose arms are falling off in a corner of the studio. All this is obvious enough. And for my part, I have only made some sentences with the help of secondhand information, scraps borrowed from others, not saying much of anything. I have stirred up images and hot air. I mull over my incompetence. Although he is still an enigma, much is known about Degas, thanks largely to Henri Loyrette, his eminent biographer. But about Marie? "You don't even know the date of her death," I tell myself over and over, depressed and insomniac. I judge myself harshly, I interrogate myself through the night: how do you know what you know, and why don't you know what you don't know? I

feel remorse for having dealt with Marie as an object of study, filled in with anecdotes the way her sculpture is filled in with bric-a-brac, but I haven't brought to it the genius she deserves. When it comes to her, her reality, I have said nothing, shown nothing. I know nothing.

I read and reread Huysmans's description, written in 1881. The sculpture is what he describes, of course, but a contemporary of Marie's is speaking, someone who literally lived at the same time as she, a witness:

> Her head painted, angled slightly back, her chin raised, her mouth half-open in her sickly, gray-brown face, which is pinched and old before its time, her hands joined together behind her back, her chest flat under a close-fitting white bodice whose cloth has been kneaded with wax, her legs in position for a fight, admirable legs that are well-accustomed to exercise, nervous and twisted, crowned as by the pavilion of her muslin skirts, her neck stiff, encircled by a leek-green ribbon, her hair falling down to her shoulders and gathered at the nape, decorated with a ribbon similar to the one around her neck, an actual pony tail, such is the dancer who becomes animated under one's gaze and seems to want to leave her pedestal.[4]

What impresses me in this portrait, and what I discover after the umpteenth reading, is the tension here between life and death. Huysmans shows the little statue as ready to "leave [its] pedestal," to become animated with the independent life of its model, and at the same

time what he is describing is a cadaver, with its mouth
half open, its face waxen, its neck stiff. Also, with its
eyes half closed, as in a face where the muscles no longer
obey the will, where the eyelids reopen although they've
been closed. I recognize this *out from under* look that
the dead sometimes have — I know my dead. When we
admire the bronze casts of the sculpture in museums,
we forget that the original was made of wax, and so we
no longer see its grayish, deathly tint. Death is a mate-
rial, death is a color that we don't want to remember.
This may have been the real reason the *Little Dancer* was
so poorly received in 1881, the quiet cause of the near-
unanimous aversion it generated. It isn't vice that makes
people shriek with horror, or insolence, or esthetic rev-
olution. But death does — the scandal of it. By using the
same material that death masks are made of, the artist
is not just embracing a tradition: he gives us to think.
About life, about death. About beginnings (age fourteen)
and resolutions (dying). At the end of a century when,
to use the words of historian Anne Carol, embalming
was "a Romantic passion," Degas used his art in service
to the crazy idea that the dead could be kept alive in
uncorrupted bodies. His small statue, which borrows
from techniques used in medicine and the manufacture
of everyday objects, is also and perhaps above all a medi-
tation on the power of artistic creation and of sculpture
in particular. One of the first visitors to the exhibition
compared the *Little Dancer* to an Egyptian mummy, to
general puzzlement. All the same…there's a modicum

of embalmment to this statue. Like photography, an art that also interested Degas in those years, and like film, which was in its infancy, Degas's sculpture seems to say "this once existed," a phrase whose inevitable pendant, as Barthes has observed, is "this no longer exists." About photography, Barthes says, "It certifies, if we can put it this way, that the corpse is alive...The photograph is the living image of something dead."[5] But we could say the opposite about this wax statue: it is the dead representation of a living person. Marie was there, right in front of Degas, talking, laughing maybe, protesting, heaving sighs, and he sculpted her muscles and skin with all possible accuracy. But her hair is sticky with wax, and her face has a gray-brown hue; her bodice and slippers are smeared with wax, as with a layer of glue or mud. This gives the work its genius, its power to exercise a painful fascination: she rises in a state of living death to confront the world, so all can see her.

I LOOK AT DAMIEN HIRST'S GIANTESS, pregnant and flayed, who in her own way sends us back to questions of life and death, and I ask myself without finding any answer: "Did Marie van Goethem have children?" And also: "Where is she now? Where is her body?"

AFTER A WEEK, unable to bear the agonies of my own imposture, I decided to return to Marie, to her most

basic aspects. What I needed was to gather everything that was known about her, everything that came from a trustworthy source, leaving aside everything that had been imagined or conjectured from generalities. I didn't want to know about the life of a little Opera rat of the nineteenth century or a young model, I wanted to know about her life, whose length was a mystery. As Barthes would have said, she "protested her former existence," and I heard her calls. I had learned a lot, but it wasn't enough. I couldn't abandon her without doing more for her memory.

My investigation met a first obstacle in that the best experts gave contradictory information—different dates, different versions of such and such a supposedly well-known episode—according to whether they consulted, as I had, one or another of the previously published articles. Each trusted his predecessors, and no one, in consequence, had gone to the trouble of fact checking, myself included. I thought of what the memoirist Annie Ernaux had said to me one day in an interview: "When I write, I need to be engaged through and through with truth-finding, even to the point of obsession—going back to original sites, inventing no detail."[6] This is not my natural mode. I am not normally fixated on accuracy, I let my memory use its imagination. But in this case, it wasn't about my own memories. I wanted to be honest in my dealings with this tiny life, not settle for what everyone was saying about it. I wanted to pick up her trace in Paris, where she was born, where she had

disappeared one day into an unknown but inescapable misfortune. A work by Patrick Modiano was my companion, its sentences engraved in my mind: "I think of her in spite of myself, sensing an echo of her presence in this neighborhood or that," he wrote about the unknown Jewish girl whose traces he followed as far as Auschwitz.[7] His book, which I read and reread, is full of unanswered questions, of unfinished answers, of "maybes" and "nevers." The last paragraph starts with this observation: "I shall never know how she spent her days," and ends suspended on "her secret. A poor and precious secret."[8] For me the secret was in the statue, a secret now made of bronze. But the soul of this secret still hovered in the air. Marie van Goethem had become my Dora Bruder.

I had no idea how to go about my task. I'm not a historian. I felt that at this stage of my project, only the archive could provide orientation and at the same time give me peace, possibly. But I didn't know where to look or whom to ask.

I then remembered that of all the authors I had consulted in the course of my work, only one, who was often cited, had seemed to light the way ahead and, in some sense, carry out my project. It was Martine Kahane, the head librarian at the Paris National Opera, who, in 1998, had published in the *Revue du Musée d'Orsay* an article entitled "Investigation into Degas's *Little Dancer Aged Fourteen.*" What prompted her research was unusual. She had been asked by her colleague Anne Pingeot, a curator at the Musée d'Orsay, to consider how a new tutu might

be made for the sculpture, as the costume workshop at the Paris Opera had an excellent reputation. This was in 1997. A controversy surrounded the tutu, however, because the original was long gone and the specialists disagreed about the garment's color, length, and even its material. In its concreteness, the tutu led back to the living body of its wearer. "Interested as I was in the young lady's skirts," wrote Martine Kahane, "I quickly came to ask myself questions about her identity...It struck me that to know more about Marie van Goethem, I would have to research her family history."[9] The Opera librarian, therefore, began searching energetically through the available archives, believing that "young Marie was still a part of the organization."

Impatient to learn more, I obtained Martine Kahane's contact information and wrote her straight off, bombarding her with questions. She didn't take long to answer, clearly pleased and amused that someone was picking up the torch she had lit twenty years earlier. Retired, she no longer lived in Paris, but she was coming to the capital in a few weeks. We could meet, and she would bring me everything she had on the subject.

Waiting for the appointed day, I typed on my keyboard, "vital records Paris nineteenth century." This would allow me to personally check Marie's birthdate, which varied inexplicably according to the source, with some setting the date in 1864 and others, the majority, in 1865, but always in Paris's Ninth Arrondissement. The site for the Paris Archives popped up immediately—it

was so easy, how had I not thought of it earlier? The vital statistics records have recently been digitized and can be searched back to 1860. You consult an alphabetical index of names, divided into decades and subdivided by arrondissement, listing every person born or married in Paris and every person who died there. The full records, which include descendants, are open only to family members, who are required to give proof of identity and kinship, but the short-form records are available online to all. So you can surf incognito on the Internet for the lives, loves, and deaths that transpired in Paris from 1860 to 1974, with interruptions corresponding to the great upheavals of history — the Paris Commune, the two world wars — and these gaps in the chronology of the vital records are like holes in the body of humanity.

I went to the data indexed by decades and typed in: "kind of record: birth," "decade: 1860–1872," "arrondissement: Ninth," "name of person: Van Goethem." My hands trembled, I hit the wrong key several times, I felt my heart rate go up. What was I afraid of? The violent incursion of reality into my little story, as would happen a few moments later when I zoomed into the left-hand page of folio nine? Could I foresee that reality was going to leap out and grab me in the form of strangers born more than a hundred years ago? Because, of course, she wasn't alone on the page, Marie Geneviève van Goethem, born June 7, 1865. She was there among dozens and dozens of Van Thises and Van Thats: Van Germies, Vanberck, Van Houtte, Van Isacker, hundreds of Belgian

immigrants packed together in the vital records of the Ninth Arrondissement. She was there with her youngest sister, Louise-Joséphine, born July 19, 1870. There was no mention of the eldest, Antoinette, who had been born in Belgium. I thought of the impoverished family that had left Brussels in hopes of a better life, or at least of a less harsh one. In 1881, close to half a million Belgians had already emigrated to France, crossing the border on foot to settle in the northern provinces or continue on to Paris. Italians, Spaniards, insurgent Poles, and Jews fleeing the pogroms had done the same. The vital records offered the names of their children at this end of the alphabet in bulk quantities: Urrabieta, Uruski, Verlek, Volpini, mixed in with names grounded in the French provinces: Vavasseur, Vidal, Vigneron, and Vilain. I thought of the refugees who now arrive in France every day with their children, of their destitution, greater even than in the nineteenth century, the insurmountable obstacles that prevent them from becoming registered anywhere, or belonging anywhere. I thought of a news program I had seen about ten- and eleven-year-old children who had gone to school in Syria and were now working in Turkish textile factories to make money for their families. I remembered the fourteen-year-old boy who liked school so much and who now stared into the camera dully, saying that it was hard to give everything up, that he was gradually forgetting all he had learned, but that at least by working he was able to feed his parents and his sisters. What will become of him? Will he return

to school one day? Will this child die, slaving to make T-shirts for the likes of us? Time doesn't move ahead for everyone at the same pace. This Syrian boy and Marie van Goethem were born a century and a half apart, they are both fourteen, both foreigners, and their condition is the same, they share the same physical and mental suffering. It's also what Degas was telling us with his *Little Dancer*, that his own present time is universal, that he projects it into all times, that he informs the future with his hands.

My thoughts lingered on these unhappy children, both dead and alive. I thought of the siege of Paris in 1870, during which Marie, then five years old, must have been terrified at the sound of the cannons, just as the children in Aleppo would have been terrified when the bombs rained down. How do you survive the terror, the cold, the hunger, the pain? And was she still alive during World War I? When I emerged from my startled reflection, the page of vital records was still posted on my screen. Examining the entries a second time, I noticed something that had escaped me at first. Just above Marie Geneviève van Goethem, born on June 7, 1865, there was a Marie van Goethem, born on February 17, 1864. Strange discovery. So there were two Maries, two birthdates. Which was the little dancer? I then consulted the corresponding records. They were sisters, born sixteen months apart—I didn't need to make the calculation, because I myself had given birth to two children, one of them in February 1994 and the other in June 1995. The correspondence struck me immediately,

130 years later, and I realized at once, following the parallel, that one of the two must have died, as had happened to me. I called up the death records for the same decade and arrondissement and found her. A Marie van Goethem had died on March 7, 1864, aged eighteen days. This was what explained the confusion about birthdates in the articles on the *Little Dancer*. The parents, as was often the case, had given their next daughter the name of her dead sister, wanting to pass on their own names to their descendants. The birth certificates named the father, Antoine van Goethem, tailor (who had already bestowed his Christian name on his eldest, Antoinette, born in Belgium), and the mother, Marie van Volson. They were married in Brussels in 1857. On the same page of the alphabetical index, on the line above, there was another Van Goethem, Jean-Baptiste, who died on February 14, 1862. The record confirmed that it was their first and only son, born in Brussels, who died in Paris at the age of three years, five months.

Archives are an abyss, a fascinating spiral that draws you in irresistibly. Every detail takes on magnified importance, every fact registers as a sign, as in a love story, everything is there to be interpreted, obsessed over. Archives foster a pathology all their own, which is possibly aggravated in a novelist. There's a suffering associated with archives, their power over the emotions is extraordinary, violent, dangerous. Reality is everywhere, in the numbers on the folios and the certificates, in the black ink of the clerk's handwriting, penned in greater or

lesser haste, with more or less artistry. The calligraphy, ink blots, downstrokes and upstrokes, bring back school-room memories. The real inheres in the details: record No. 289, Marie, born February 17, at 1:00 a.m., in her parents' home, 34 rue Lamartine, the father's signature appended. Record No. 1033, Wednesday, June 7, 1865 — it was a Wednesday, why does this bring tears to my eyes? Marie Geneviève, "born this morning at eight o'clock, at her father and mother's residence, place Bréda, No. 8." Since the previous year, the family had moved to the place Bréda, known as one of the most squalid precincts of Paris. "Statement given, in the father's absence, by Virginie Laury, midwife" and signed by two witnesses, two "office boys" residing on the rue Pigalle. Why was the father not present at the birth of Marie Geneviève? Was he traveling, or on the lam, or dead? The death certificate of Marie, in 1864, was signed by the still-present father and a young witness, "Pierre, aged 25, polisher." The vital records bristle with these working-class trades, some of which are mysterious, while others still existed during my childhood: water carrier, lemonade vendor, coalman, knife grinder, noodle maker (shades of *Père Goriot*)...In the record books, the wives never have a profession: even when they worked, it wasn't mentioned. Only the man counted, and his work was his strength. The work of women signaled their weakness, the fact that they were spinsters or widows.

On March 7, 1864, five other persons died aside from Marie in Paris's Ninth Arrondissement: a little girl

of two, declaration made by her father, day laborer; a stillborn baby, "stated to have come from its mother's womb last night at four o'clock"; a forty-year-old perfumer, spinster; a woman of thirty-five, daughter of a porcelain painter; a landlord, aged twenty-eight, born in New York, declaration made by an agent of the American consulate. Death makes all these creatures equal, makes them affecting and poetic; each becomes a potential person, a romantic specter, a ghost story.

I wandered for a bit among this handwritten crowd, then came back to the little dancer. Marie (Geneviève) van Goethem. It's not all that easy, I knew, from my own experience and from watching my daughter's, it's not all that easy to develop cheerfully in the wake of a dead sibling, especially when you carry the weight of that person's first name. I also remembered Vincent van Gogh, who bore the first name of a stillborn brother.

Having trawled the decennial indexes for 1860–1872 and 1873–1882, examining the records for all of the arrondissements in Paris, I found that I had collected a large number of Van Goethems. The surname, it appears, was a common one in Belgium, equivalent to "Martin" or "Durand" in France. It was difficult under the conditions to identify who might be close family to Marie, although it was likely that a cousin, an uncle, or an aunt had emigrated from Belgium with them and formed part of their circle. But how to be sure? The only certainty was in the group of immediate siblings. Marie van Goethem, the mother, had five children, two of whom died at a

young age, which was not unusual at the time, especially in those surroundings. Pushing my research forward into subsequent decades (I couldn't stop, the hours flew by without a thought of food or drink, the need to know outweighed everything), my heart suddenly skipped a beat, I thought I had found her, the little dancer: Marie van Goethem, died October 30, 1908—forty-three, that would make her. Age forty-three, it doesn't surprise me that she died young. But the full death certificate showed that I was wrong. It was the mother, née Van Volson, widow of Antoine van Goethem, "aged seventy, no profession, residing 3 rue Gaillard, died at the Opéra this 28 October, at 5:30 in the evening." The certificate was drawn up two days later, on October 30, and was signed by two witnesses, "no relation."

Died at the Paris Opera! I couldn't get over it. In some sense, the mother of the little dancer had died in a Degas painting. Was she in the wings or, although declared to have "no profession," in a dressing room helping with costume changes? Was she seated during a rehearsal on the mothers' bench, which Degas painted in the background of several of his canvases? But only one of her daughters was still at the Paris Opera, and she was no longer a little rat: Louise-Joséphine would have been thirty-six, she had recently become a teacher after a brilliant career. I had no great opinion of this mother who had probably led two of her daughters into prostitution, so why was I so moved? My imagination, stimulated by the archive, was gaining the upper hand. I could

see the scene. This seventy-year-old mother who continued to accompany her youngest daughter to the Opera moved me, even though I knew that the real story was probably grimmer. The widow Van Goethem was most likely clinging to a part-time position that brought in a few francs and also to this daughter who owed her success to her. "You won't forget your mother when you're happily settled" was, according to Théophile Gautier, the sentence most often heard in the wings of the Paris Opera. But I imagined her dying suddenly while watching her successful youngest child — did the daughter run to her mother on seeing her collapse, the victim of a stroke, or was she indifferent to the passing of a grasping and unloving parent? I preferred the first hypothesis, or rather, the first imagined scene. In my mind, the mother and daughter were the last survivors of the family. The father had died, and neither of the other two sisters was mentioned in the death certificate, which was signed by witnesses identified as "no relation." I imagined Louise-Joséphine as all the more shattered because no trace of Marie or Antoinette made an appearance in my little improvised story. It was stupid, but reading the circumstances of this death, imagining the scene, I was suddenly convinced that the other sisters were dead.

Martine Kahane, whom I met two weeks later, gave my suspicion credence. She provided me with the chronology she had drawn up for the Van Goethem family. Antoinette, the eldest daughter, died at the age of thirty-seven, on March 20, 1898. Her death at 68 rue des

Chantiers, in Versailles, was attested by two witnesses, "in the absence of kin." Her mother and at least one of her sisters were still living, but she had apparently dropped all contact with them, and the neighbors had no knowledge of their whereabouts. The vital records describe her as a "spinster, living from rents." Her first youth and her clashes with the courts behind her, Antoinette had managed to find a rich protector and settle quietly outside of Paris, her escapades a thing of the past. Many years before, at the age of twenty-one, she had figured in the records of the lower court of the Seine district. Penal court No. II sentenced "the young woman Vangoethen [sic] to three months' imprisonment and a fine of sixteen francs seventy-six centimes, plus three francs' postage. If the fine is not forthcoming, imprisonment for debt will be limited to five days." Antoinette stole seven hundred francs from the wallet of one of her "clients" while dining with him in a private room. The news gazettes of the time, quoting from the police report, indicate that Antoinette van Goethem was arrested at the train station after the theft, on July 20, 1882, while trying to escape to Belgium "with her mother and sister." Her sister was Marie, who had been fired from the Paris Opera two months earlier. *Révoquée* (dismissed): this is the word that appears in the account books of the Paris Opera, dated May 1882. Leafing through the pages photocopied by Martine Kahane, I found the works and days of the little dancer evoked in affecting detail. Each little rat had her line in the ledger,

which showed her job title (Marie never progressed beyond the lowest rank, second class), her wages by month and by year, and the various withholdings against the "net balance owed." The last two columns are headed "Attendance" and "Remarks." It's in the last of these that Marie Vangoenthem (the spelling is still wrong) is entered as "dismissed" and "resigns." Prior to this fateful day, she received 71.25 francs net per month, though often less when fines were levied against the total. In January 1882, for instance, she received only 63.75 francs, having been charged 7.50 francs in fines. In April 1882, she received only 35.65 francs. In the margin is the following remark: "15 days without wages." She was fired the next month.

The Paris Opera's record books allow us to follow Marie's progress, or rather her path to perdition, which parallels her beginnings as an artist's model. The more she posed for Degas—and no doubt for other lesser-known artists—the less assiduously she rehearsed for the ballet. The painter of dancers paid much more than the management of the Palais Garnier. A four- or five-hour session posing for Degas earned her two or three times what she received for a full day at the Paris Opera and left her less tired and with more free time for herself. The truth was, she had no great talent for dance, and the bohemian milieu, with its cafés and cabarets, was much more lively. The Montmartre cabaret Le Chat Noir had just opened, in November 1881, and she often went there. Yet after her expulsion from the Paris

Opera, she turns up nowhere else, with the exception of the train station to which she accompanied her fleeing sister. It's the last unquestionable trace of her that we have. She seems to have lived in Belgium for a time in the early 1890s, and a Marie van Goethem resided briefly at 43 rue Fontaine in Paris in 1893, but it could have been her mother. The trail stops there: nothing further about her in Degas's *Notebooks*, nothing in the vital statistics records or the police files. Neither a marriage, nor the birth of a child, nor a death is recorded for any of the twenty arrondissements in Paris. Did she remain unmarried, as her sisters did? Did she find a protector who sheltered her from want, like Antoinette, or one who offered her an honorable if somewhat marginalized life, like Louise-Joséphine, who would die as the respected mistress of the painter Fernand Quignon? We don't know. And none of the Van Goethems I talked to who are currently listed in the phonebook had heard tell of an ancestress who posed for Degas. Unlike her two sisters, Marie disappeared without a trace. The little dancer flew away. Her mortal remains most likely lie not in a sepulcher but a communal grave. In the cemeteries where I vainly searched for her final resting place, I was often asked, "Marie van Goethem? Is she famous?"

WE ARE SITTING THERE, Martine Kahane and I, with our cups of hot chocolate. It is the winter of 2016, and copies of the archives are scattered over the table. We are hard

at it, trying to figure out what might have happened in 1882. Martine says something about the Van Goethems' living standard, which must have dipped when Marie was dismissed from the Paris Opera. That would explain why Antoinette was stealing money: in May 1882, the family could no longer count on Marie's wages. Only Louise-Joséphine was still on the payroll, but she was a beginner and received very little. In July, Antoinette stole seven hundred francs so that they could stay alive and pay their rent. Marie's firing was decisive, no doubt about it, says Martine Kahane.

I say nothing, I'm afraid my voice will quaver if I put my thought into words, our common thought. The merry-go-round of grief starts up again. If Edgar Degas hadn't chosen Marie as his model for the *Little Dancer,* she would probably have stayed on at the Paris Opera. She might not have had her younger sister's career, but who can say? By sticking to dance, she would have avoided the descent into hell whose signs are all too clear. Did she think she would have a better life as a model—less pain and more money? Did she quickly realize her error? And where was Degas in all this? Did he give Marie more work after her setbacks? Or did she really only figure in his life as an artist for four or five years? All the drawings and canvases in which she seems to appear are clustered within a short period around 1880. Is that her, behind the features of the high-cheeked milliner, drawn in charcoal in 1882? And her again in the background of *The Green Dancer,* adjusting her shoulder

strap? We also seem to recognize her cheeks and her forehead in *The Singer in Green,* dated 1884. Subsequently, in his later work, other models vie for Degas's favor. Did he help her, rescue her? There is no evidence that he interceded on her behalf with Vaucorbeil, the director of the Paris Opera, as he did for others — Mademoiselle Chabot, for instance, a ballerina at the Opera who wanted a raise, and about whom he wrote to Ludovic Halévy in 1883: "You must know what it's like when a dancer wants you to plead her case. She pops in twice a day to see if you have put in a word, if you have written a line...I've never encountered such a maniac before. And she wants it to happen immediately. She would carry you in her arms to the Opera wrapped in a blanket if she could!"[10] Several letters dated 1880–1884 show that for all his apparent annoyance, Degas helped his "little darlings" of the Palais Garnier. Did Marie have less confidence in herself, less charm, or did she simply not want to be reinstated? In any case, she asked for nothing, and he did nothing. As I read Daniel Halévy's memoir of Degas, I felt a pang at this cheerful passage from a letter the painter had written: "Next Thursday, then, June 15, 1882, there will be a little housewarming soiree at 21 rue Pigalle, in the prettiest little fourth-floor apartment in the whole quartier."[11] Marie had just been fired from the Paris Opera, Antoinette would soon go to prison, and Degas was moving into a prettier apartment.

The divergence in their lines of life would become even more marked on the great palm of time. Did Degas

even see Marie in the years that followed? Neither his notebooks nor the newspapers mention her after 1882, although he continued to rework her sculpture. "I've made many changes to the small wax," he wrote in June 1889.[12] It's as though Degas's statue had absorbed her essential life and there was nothing left for her to do—like the heroine of Edgar Allan Poe's "The Oval Portrait"—but vanish from the annals of time. Sculpted by Degas's vision and desire, had she no recourse but to fade away? Is this too steep a price to pay for art, or could she have dreamt of no greater heights for her small life? I think back to the definition that the novelist Pierre Michon uses to avoid feeling either condescension or dejection over a person's circumstances: "I call any man small whose fate does not measure up to the plan, which is to say everyone."[13] Rereading these words, I find they apply neither to Degas nor to Marie van Goethem. Degas's fate measured up to his plan. As for Marie, her fate cannot be measured, because she had no plan—it certainly wasn't her plan to be an icon of modern art and to maintain her unvarying pose in all the greatest museums in the world. Yet knowing nothing about her death, I have a tendency to confuse it with Degas's old age, which was atrociously lonely. I even find myself believing sometimes that the hours-long walks that the painter took every day at the end of his life, and whose meaning or point no one around him could understand, were his unconscious way of staying with his little Opera rats, who were nicknamed *marcheuses*, or

walkers. He could no longer see them or paint them or sculpt them, but he still walked with them. The funeral oration for Edgar Degas inventoried "nonexistent loves, family difficulties, ruined friendships" and the transformation of an "innate shyness" into a "furious pursuit of unhappiness":[14] I find myself unable to disentangle this documented end of Degas's life from Marie's, about which I know nothing. "I cry often enough over my poor life," Degas wrote.[15] The shade of Marie melts into the deep shadow that Degas himself disappeared into. Her ghost is carried off, buried with his remains. Nothing can separate them any longer. If we take their two lives as one, at that point in time when their trajectories intersected, like a momentary couple glimpsed through a pane of glass, the resulting life is neither resounding nor insignificant. It is a life of hard work. And also sadness, I believe. Yet it is a remarkable life, sovereign and vast in import. Both of them while still alive, she posing and he sculpting, had the experience of death. The little statue restores their absent presence. It is their monument, their requiem.

I AM HAVING A HARD TIME ENDING THIS BOOK, because I'm having a hard time letting Marie go. I never thought I would say something along the lines of "I'm sorry to leave my subject, it's become an obsession. I can't stop thinking about this character…" Authors who make that kind of statement normally exasperate me, they seem conventional, hypocritical, ridiculous. Yet that is what I feel today toward the little dancer — *my* little dancer, I almost wrote. It may be because she had an actual body. Though I may have seen it only in wax or in bronze, this body existed, it crossed Paris streets, where I can follow its trace even today. I can go to 36 rue de Douai and find the building where this body sheltered while posing for Degas — in fact, I have done so, but the hovel she lived in must have been torn down in the mid-1950s, as an economy hotel built of block concrete stands there today. I can go to the Opéra Garnier to see the stage where she danced, although the ceiling is no longer the same because of renovations. But here she extended her legs toward the red velvet of the curtains and the gilt of the paneling, rounded her arms under the complex

machinery that raises and lowers the flats, looked with her eyes at this hall where the bourgeois continue to come in search of desire. She is a person and not a character, even if the sculpture, in a sense, provides a narrative and gives her the status of one. I know that she lived, I did not invent her life, I don't like inventing life. My grandmother, born in 1907, could have crossed paths with her — had Marie already died by that point, the forty-two-year mark? No one knows. In any case, she could have met my great-grandmother, who was born in 1890, a penniless dressmaker's apprentice and a single mother. I met her — she died in 1972. Thanks to my ancestor, a link exists between Marie and me, a link in time, or so I feel. It wasn't all that long ago, in the end. I no longer belong to the working class that, in common with Marie, my great-grandmother hailed from. She came to Paris from the mining district in northern France, but I remember her. I remember seeing her in the hair salon that she'd bought with her own savings, talking about how she used to burn the tips of dancers' hair with a candle to strengthen and beautify it before a performance. I also remember that my father formally forbade her to burn the tips of my hair.

A few days ago, I went back to see "her" in the Musée d'Orsay. She was there, stately as ever, seeming to contemplate the masterworks of Degas on the walls around her from behind half-closed lids. By way of farewell, I took dozens of photographs of her — that "two-dimensional death." A young woman who had been

quietly watching me for some time approached, held out her cell phone, and asked in English if I might take her photograph next to the statue. I said yes. She bid me wait a moment while she posed, and she assumed the exact position of the little dancer. She must have made her plan beforehand, because she had tied back her long hair with a green ribbon, and she assumed her stance in seconds—feet in fourth position, hands clasped behind her back, chin raised. For my part, I had no time to quiet my heart, which was suddenly pounding, but why? I took four snapshots, just to be sure, given my trembling hands. The young woman was Australian. No, she wasn't a dancer. It was just that she had heard a great deal about this sculpture as a child, and her grandmother had particularly recommended that she visit it during her stay in Paris. So that was it, she was going to bring back this photograph of the two of them, it would make a nice surprise, thank you.

WHEN I ARRIVED HOME, still keyed up—but why?—I thought back to my own grandmother, with whom I lived all through my childhood. Had she ever been to a museum? Highly unlikely. I realized that I knew nothing about her birth, her childhood—even less than I did about Marie. The one thing I knew—the fact had made an impression on me—was that she'd been born in Paris: she was proud of being the only Parisian in our provincial family. Her mother, Sophie, gotten with child by a boy who quickly

vanished, had left her hometown of Hénin-Liétard to give birth anonymously in the capital away from wagging tongues, strongly encouraged to go into exile, if not actually driven to it, by an unloving mother. A start in life worthy of Zola. I wondered where she had landed in the strange and bewildering city. Had it been in the Ninth Arrondissement, like the Van Goethems, a neighborhood that was still very poor at the dawn of the new century? It would have made another link between us.

Having learned to navigate the vital records archive, I started an Internet search. My grandmother did not appear in the decennial indexes for the Ninth Arrondissement. I then started working through all of Paris's neighborhoods. It took me a while, but when I finally reached the Eighth Arrondissement, there she was: Marcelle Jeanne Liétard, stuck in as an afterthought between two lines of the ledger, as if the clerk had forgotten her. It fit with my grandmother somehow, this last-minute inclusion—a fatherless child, banned from home, written into the ledger but not given her own space, born between the lines. It was moving to find her there, my grandmother, buried in this long list handwritten in black ink, with capital letters of the kind once taught in schools, solemnly penned. All the names made me dizzy, as they wouldn't have if printed. Here was the history of man written out by hand, the endless cycle of humanity and also of the drudging clerks laboriously scribbling, correcting their mistakes, disappearing only to be replaced in the ledger by another handwriting, less

firm and legible, or else more finely turned, the changes in penmanship mirroring on a human scale the ceaseless progress of time, the passing of the baton.

As my grandmother was born after 1903, her birth certificate wasn't available online. I had to request it, and it would be sent to me in the mail. I did so. The document arrived ten days later, posted from the town hall of the Eighth Arrondissement. In the meantime, I wondered what I'd find recorded there. I was expecting the words "father unknown," but the phrase I had to decipher was "father not discriminated." I understood the meaning of this bureaucratic language well enough, but the word chilled me to the bone. I knew that the root of the word "discriminate" came from a Greek word originally meaning "to judge," "to separate," "to choose," but it was the word "crime" that I heard, along with its implication of my great-grandparents' immorality. Of all the possible men, the authorities had not been able to determine which had made my great-grandmother pregnant; worse yet, of all the criminals in existence, they had not established which was my grandmother's father. For a moment, the word "incriminated" fanned out its ghostly palette, from prostitution to the *apaches,* and the "criminal" little dancer. I came back to my senses and reread the document, my heart beating strongly all the same, analyzing, weighing, studying every detail of the birth certificate of my grandmother, Marcelle Jeanne, born in the year 1907, on October 1 at nine o'clock in the evening, at 208 rue du Faubourg-Saint-Honoré. The address, today chic,

belonged then to a charity hospital, a former Sisters of Charity hospice. To my query, Google Maps returned the hôtel Beaujon, a magnificent eighteenth-century town house, where a variety of cultural organizations are quartered today. Marcelle Jeanne, I read, "daughter of Sophie Liétard, domestic servant, residing in Paris, 135 avenue de Villiers." A much less elegant address, of course, even if the Google photo makes the recently restored facade of this Haussmannian building look quite appealing.

But what surprised me most was Sophie's stated occupation. Before owning a perfume store and hair salon in Dijon, my great-grandmother claimed to have been a seamstress. When I read "domestic servant," tears came to my eyes. I had just discovered, many years after the fact, what she had always kept hidden, no doubt a private shame. To serve in someone else's household, to obey orders, this must have been a major humiliation for her, worse even than being an unwed mother. When I knew her, she was always so proud to set off early in the morning "to the store." Even in her eighties, she was the first to rise and reached the store before any of her employees. It was only normal, as she was "the boss." Her daughter, my grandmother, never worked. Of that too she was proud.

The birth certificate mentioned another strange thing. In the margin, beside a variety of later notations about marriage and death, there was a note indicating that Sophie Joseph Liétard had "recognized as her daughter the child named herein" on October 17, 1907, which

is to say more than two weeks after my grandmother's birth. As with Marie van Goethem, the archive did little to fill in the gaps, instead opening chasms to speculation. Why, for instance, did the birth certificate distinguish between the birth itself and its acknowledgment? For the mother, it makes no sense: *mater certissima*. And yet...what could the delay mean? That Sophie was ill and therefore could not officially claim her daughter, so that the child was registered but not legally recognized? Or does the interval point to a hesitation about keeping the child, an inclination to abandon it after bringing it into the world? I didn't know, but even without knowing, I understood, my empathy was total. The fact of it was, I said to myself, brushing the doubts away, the fact of it was that she hadn't abandoned her daughter, that Sophie Joseph (another oddity, this male given name appended to Sophie—it must have been her father's), that Sophie Joseph valiantly raised Marcelle Jeanne. They both lived for several years in Paris, between 1907 and 1913, at which point, for unknown reasons, they moved to Dijon. Mother and daughter were never afterward separated. I always knew them together, living under the same roof with my grandfather, through whom they had been elevated to the bourgeoisie. My grandmother in particular was well known for her elegance and her deportment. My great-grandmother, though, always preserved a slightly rough edge, a burr from her populist background that she had no interest in polishing away. Despite her son-in-law's offers, she never agreed to have

a domestic servant. In a black-and-white photograph I have of her, at the age of about forty-five, she looks strangely like Louise-Joséphine van Goethem at that age, when she was a teacher at the Paris Opera—the same pleasant but not particularly pretty features, the same stocky, corseted body, the same frank gaze. Sophie and Marcelle might have crossed paths with the little dancer while out walking in Paris. They might also have seen Degas, who died in 1917, and who ambled around the city for several hours a day in the last years of his life, crossing it from end to end as his doctor had advised him. It's perfectly possible. When it comes to Marie, I don't know.

When I was a child, in Dijon, I took classical dance, like most little girls. I went twice a week with my sister Dominique to a highly regarded dance school near the theater. The teacher was a big, imposing man who ran his world with a stick, literally—he corrected our position with the help of a switch that never left his hand. He frightened us, threatened us with the most horrible future if we didn't listen to him. I was seven or eight years old, my sister was ten. He was convinced that we had great talent. Dominique had flexibility, I had grace, he would tell my mother or my grandmother when they accompanied us to our lessons. "Together, the two of you could be a prima ballerina," my grandfather joked. But the big man was not joking. He was convinced that if the two of us worked like dervishes, we could get a place as little rats in the Paris Opera. In the footsteps of Pauline

and Virginie, who were storybook heroines under the French Third Republic, would come Dominique and Laurence (me), future stars in the firmament of ballet idols. We had the potential, and it was only left to us to make the required effort, by taking additional courses, by rehearsing at home, by walking with a dictionary on our heads. He would tell us when he thought we were ready, and he would take us personally to the entrance exam. The Paris Opera!!! I think this prospect did not really fulfill my sister's dreams, but it did mine. I had seen the outside of the Palais Garnier on my first trip to Paris with my mother the summer before, we had walked past its imposing facade. I had tripped up and down the grand staircase *en pointe*, my arms rounded, before going to the Musée Grévin to look at the wax figures. The building impressed me. I pestered my mother every morning to make my hair into the tight, round bun that is the mark of a ballerina. To show my friends and the world at large (the passersby in Dijon) how well I danced, I wore my ballet slippers into the street and made arabesques on the sidewalk in front of my house. I listened to *Swan Lake* on repeat. All my dolls had tutus and a rhinestone hairband.

One day when my sister was taking a shower, my mother noticed the red welts on her thighs. "What's that?" she asked. It was where the teacher had smacked my sister across the legs with his switch during dance class: "Fourth position! I said fourth!" My mother didn't know what to do. On the one hand she felt respect for

the work of the artist and a sense that discipline was necessary, but the physical violence made her uneasy. In the end, she decided to consult my father. My sister hiked up her skirt to show him her welts. "What sort of pervert is he?" said my father. "Under no circumstance will my girls return to him, it's finished. He should be glad I'm not filing a lawsuit." And that was it. My mother didn't try to find us another dance class, or the only available ones were too far away and would have required us to go by car. I don't remember if I pleaded with my parents. I must have decided to go along with the family decision: my sister and I had a real protector, not at all like yours, Marie, and we had parents who loved us, even if they didn't understand anything. At my grandmother's house, where the windows gave onto the theater, I made up for it by watching rehearsals through the curtains whenever a ballet was to be performed.

After my dance studies came to an abrupt end, I continued for a time to do my exercises. I would put on my demi-pointe shoes and practice my positions holding on to the bedstead. When no one else was in the apartment, I would cross the living room back and forth on tiptoe with a dictionary balanced on my head—a volume of the illustrated *Larousse,* not always the same one, which I borrowed from my parents' glassed-in bookcase. Then one day, I felt I'd had enough of prancing toward a dead future. I took the dictionary off my head, sat down, laid it across my knees, and cracked it open. Another life opened to me then, which I am still living.

Time has passed, and I still love dance. But I didn't pass that love on. At the age when you, Marie, were a little rat and I was dreaming of becoming one, my daughter was entirely obsessed with soccer. The one time in grammar school when she had to dance for a year-end assembly, she refused to put her hair in a bun, sent the tutu packing, and danced the entire ballet in overalls, chin held high, with that little air of independence you would have liked, Marie. The audience reacted with consternation: such insolence in so small a girl. It's just that things are not the same for little girls, the age of happiness has moved to other playing fields. I still like dance, especially modern dance; the magic of tutus and pointe shoes has faded, but not the magic of bodies in motion. I subscribe, as Degas did, to dance performances, not returning thirty nights in a row as he was known to do, but still sometimes revisiting a program four or five times. I like to be in front, as close as possible to the stage, so that I can see the dancers' faces, male and female, their glistening bodies, their tremulousness. Dance often makes me cry, I'm not sure why. Maybe it's the art that tells me most clearly that I'm going to die. Maybe it's the art that tells me most clearly that I'm alive. Or it may just be that it allows me to "dance on my grief."[1]

WHEN I STARTED THINKING ABOUT WRITING THIS STORY, playing with the material as writers do, I originally thought I would address the little dancer directly, make this text a

long letter to her. I tried writing her using the familiar *tu*, as though she were my own daughter or someone in my family. But it didn't work. There was something artificial and pretentious about it, the familiarity seeming almost sacrilegious. Now that I'm at the end of my tale, it no longer seems so wrong, as though the text and the archival research have woven a link between us and for a moment made this pas de deux possible.

I felt little sympathy toward Degas when I started this work. It wasn't my ambition, as Zola said about Manet, to re-create "in living actuality, a man with all his limbs, all his nerves and all his heart, all his dreams and all his flesh,"[2] but rather to form a sort of intuition about Degas that would allow me to draw close to him, and thus to you, Marie. He was solitary, intransigent, sarcastic, and rarely tender. I learned to know and love him as he was, or as I sense him to have been, even if I blame him for having apparently dropped you from his acquaintance. "I would like to be celebrated and unknown," he said.[3] No doubt it applied to you too, Marie. But on the surface, this is not the case: he is famous, and you are unknown. In reality, the two of you are joined for all eternity (I know, he didn't like the word, nor the idea); let's say, then, that the two of you are at the same time dead and eternal. You will always be fourteen years old, always three feet tall, like a three-year-old. As I finish telling your story, I find myself remembering that other statuette where your face is recognizable. You wear a little hat, a jacket with a shawl collar, and a long skirt.

You're holding a pile of books, and you're very chic. *The Schoolgirl* is the title. I imagine you posing for Degas for hours in these borrowed clothes, carrying books you will never read. What books were they? Dickens, Rousseau, Cervantes — the painter's favorite authors, grabbed at random for you to hold? You look as though you're walking calmly through the streets, on your way to school. This is the image of you that I want to keep. But there's another, possibly more in tune with the strange grief I feel in leaving you. It's from a work you may have modeled for, but which has never been found, a work described in a letter by Jacques-Émile Blanche, in June 1882, after a visit to Degas's studio. He saw, he writes, a new sculpture by Degas, a funerary monument perhaps prompted by the death of a niece: "A little girl half-lying in her coffin is eating some fruit; beside it is a bench on which the child's family can sit and mourn (for it's a tomb)."[4] I am sitting on that bench, Marie. I'm writing you from there.

ACKNOWLEDGMENTS

I OWE A LARGE DEBT OF GRATITUDE to Martine Kahane and Henri Loyrette, noted experts on Degas's work, for the kindness they showed me during our interviews and the invaluable information they gave me on the Little Dancer.

I would also like to thank Claude Perez and Jean-Raymond Fanlo, professors at the University of Aix-Marseille, and Philippe Forest, a writer and a professor at the University of Nantes, for their generous advice during the writing of my doctoral thesis, "Practice and Theory in Artistic and Literary Creation," of which the present work is an offshoot.

Finally, a thousand thanks to my editor, Alice Andigné, for her attentiveness, enthusiasm, and erudition.

NOTES

INTRODUCTION (PP. 1–10)

1. Thomas Schlesser and Bertrand Tillier, *Le Roman vrai de l'impressionisme* (Paris: Beaux-Arts Éditions, 2010), 69.

2. Richard Kendall, *Degas and the Little Dancer* (New Haven: Yale University Press, 1998), 45.

3. Jules Claretie, *Peintres et sculpteurs contemporains,* vol. 2 (Paris, 1883), quoted in Henri Loyrette, *Degas* (Paris: Fayard, 1990), 393.

4. Nina de Villard, "Exposition des artistes indépendants," *Le courier du soir,* April 23, 1881. Reprinted in Ruth Berson, *The New Painting: Impressionism 1874–1886,* vol. 1 (San Francisco: Fine Arts Museums of San Francisco, 1996), 370–371.

5. Joris-Karl Huysmans, "L'exposition des indépendants en 1881," in *Écrits sur l'art: L'Art moderne; Certains; Trois primitifs* (Paris: Flammarion, 2008), 200.

6. Ibid., 200, 203.

7. Ibid., 200.

8. Paul Mantz, "Exposition des œuvres des artistes indépendants," *Le Temps,* April 23, 1881. Reprinted in Berson, *The New Painting,* vol. 1, 356–359.

9. Edgar Degas, letter to Louis Braquaval, quoted in Jean Sutherland Boggs et al., *Degas* (New York: Metropolitan Museum of Art, 1988).

10. Daniel Halévy, *Degas parle* (Paris: Éditions Bernard de Fallois, 1995), 142.

11. Edgar Degas, *Je veux regarder par le trou de la serrure* (Paris: Mille et une nuits, 2012), 64.

ONE (PP. 11–71)

1. Edgar Degas, letter to Albert Hecht, *Lettres* (Paris: Grasset, 2011), 64.

2. According to Paul Valéry, Degas was instructed by his master, Ingres, to work "always from memory." See Paul Valéry, *Degas Dance Drawing*, in *The Collected Works of Paul Valéry,* Bollingen Series 15, vol. 12, *Degas Manet Morisot*, tr. David Paul (New York: Pantheon, 1960), 35.

3. Ambroise Vollard, *Degas* (Paris: Éditions Crès, 1924).

4. Jacques-Émile Blanche, *Propos de peintre: De David à Degas* (Paris: Éditions Émile-Paul Frères, 1927), 306.

5. François Thiébault-Sisson, "Degas sculpteur raconté par lui-même, 1897," *Le Temps,* No. 2553, August 11, 1931. Largely reprinted in Barbour et al., *Degas Sculpteur* (Paris: Gallimard, 2010), 85–87.

6. Ambroise Vollard, *Souvenirs d'un marchand de tableaux,* in Barbour et al., *Degas Sculpteur,* 42.

7. Jules Claretie, "Le mouvement parisien. L'exposition des impressionistes," *L'Indépendance belge,* April 15, 1877.

8. Théophile Gautier, "Le rat," in *Peau de tigre* (Paris: Michel Lévy Frères, 1866).

9. Ibid.

10. Ludovic Halévy, *Les Petites Cardinal* (Paris: Calmann-Lévy, 1880), quoted in Martine Kahane, "Enquête sur la *Petite Danseuse de quatorze ans* de Degas," *Revue du musée d'Orsay* 7 (Fall 1998), 55.

11. Kahane, "Enquête," 57.

12. Honoré de Balzac, *Les Comédiens sans le savoir*, in *La Comédie humaine*, vol. 7 (Paris: Gallimard, La Pléiade, 1983), 1157–1158.

13. Gautier, "Le rat."

14. Ibid.

15. Nestor Roqueplan, *Nouvelles à la main* (Paris: Lacombe, 1840).

16. Edgar Degas, quoted in Marie-Josée Parent, "La *Petite Danseuse de quatorze ans:* une analyse de la version subversive de l'œuvre" (master's thesis, University of Montreal, 2009), 89.

17. Daniel Halévy, *Degas parle* (Paris: Éditions Bernard de Fallois, 1995), 45.

18. Balzac, *Les Comédiens*, 1160.

19. Valéry, *Degas Dance Drawing*, 18.

20. Balzac, *Les Comédiens*, 1161.

21. Ibid.

22. Julien Gracq, *En lisant, en écrivant* (Paris: Corti, 2015), 78.

23. Alain Corbin, *Le Temps, le Désir et l'Horreur* (Paris: Aubier, 1991), 164.

24. Émile Zola, *Nana*, in *Les Rougon-Macquart*, vol. 2 (Paris: Gallimard, La Pléiade, 1989), 1470.

25. Joris-Karl Huysmans, "L'exposition des indépendants en 1881," in *Écrits sur l'art: L'Art moderne; Certains; Trois primitifs* (Paris: Flammarion, 2008), 252.

26. Edgar Degas, "Danseuse," *Sonnets*, quoted in Edgar Degas, *Je veux regarder par le trou de la serrure* (Paris: Mille et une nuits, 2012), 77.

27. Henri de Régnier, *Vestigia flammae*, "Médaillons de peintres," in Degas, *Je veux regarder*.

28. Valéry, *Degas Dance Drawing*, 54.

29. Ibid., 39.

30. Jacques-Émile Blanche, *Propos de peintre: De David à Degas* (Paris: Éditions Émile-Paul Frères, 1927), 298.

31. Charles Ephrussi, quoted in Henri Loyrette, *Degas* (Paris: Fayard, 1990), 393.

32. Paul Mantz, "Exposition des œuvres des artistes indépendants," *Le Temps*, April 23, 1881. Reprinted in Berson, *The New Painting*, vol. 1, 356–359.

33. Huysmans, *Écrits sur l'art*, 199.

34. Daniel Halévy, *Degas parle*, 38.

35. Ibid., 220.

36. C. Lombroso and G. Ferrero, *La Femme criminelle et la Prostituée* (Grenoble: Jérôme Millon, 1991), quoted in Parent, "La Petite Danseuse," 88.

37. Mantz, "Exposition des œuvres."

38. Douglas Druick, "La petite danseuse et les criminels: Degas moraliste?" in Musée d'Orsay, *Degas inédit* (Paris: La Documentation française, 1989).

39. Richard O'Monroy, *Madame Manchaballe* (Paris: Lévy, 1892), quoted in Kahane, "Enquête sur la *Petite Danseuse*."

40. Blanche, *Propos de peintre*, 290.

41. Edgar Degas, *Carnets*, in Degas, *Je veux regarder*, 43.

42. Paul Cézanne, letter to Émile Bernard, October 23, 1905.

43. Huysmans, *Écrits sur l'art*, 200.

44. Victor Hugo, *Les Misérables*, tr. Lee Fahnestock (New York: Signet Classics, 2013), 382.

45. George Moore, "The Painter of Modern Life," *Magazine of Art* 12 (1890), 416–425.

46. Kendall, *Degas and the Little Dancer,* 48.

47. Ibid., 63.

48. Joris-Karl Huysmans, *Écrits sur l'art: L'Art moderne; Certains; Trois primitifs* (Paris: Flammarion, 2008), 200.

49. Ibid., 126.

50. Werner Hoffmann, *Degas* (Paris: Hazan, 2007), 187.

51. Nina de Villard, "Exposition des artistes indépendants."

52. Paul Mantz, quoted in Loyrette, *Degas,* 403.

53. Blanche, *Propos de peintre,* 299.

54. Huysmans, *Écrits sur l'art,* 252.

55. Ibid., 255.

56. Valéry, *Degas Dance Drawing,* 33.

57. Pierre-Auguste Renoir, *L'Amour avec mon pinceau* (Paris: Mille et une nuits, 2009).

58. Henri Loyrette, *Degas* (Paris: Fayard, 1990), 405.

59. Daniel Halévy, *Degas parle,* 226.

60. Émile Zola, *Lettres de Paris, Le salon de 1876.* Reprinted in Berson, *The New Painting,* vol. 1. Available online at cahiers-naturalistes.com.

61. René Huyghes, quoted in Anne Pingeot and Franck Horvat, *Degas: Sculptures* (Paris: Imprimerie nationale, 1991), 21.

62. Mantz, "Exposition des œuvres."

63. Daniel Halévy, *Degas parle,* 258.

64. Ibid., 262–263.

65. Ibid., 263.

66. Ibid., 244.

67. Émile Zola, *L'Évènement,* May 11, 1866, and online at cahiers-naturalistes.com.

TWO (PP. 73–105)

1. Edgar Degas, letter to Henri Rouart, December 5, 1872, *Lettres* (Paris: Grasset, 2011), 27.

2. Quoted in Anne Pingeot and Franck Horvat, *Degas: Sculptures* (Paris: Imprimerie nationale, 1991), 13.

3. Edgar Degas, *Je veux regarder par le trou de la serrure* (Paris: Mille et une nuits, 2012), 90.

4. Paul Valéry, *Degas Dance Drawing*, in *The Collected Works of Paul Valéry*, Bollingen Series 15, vol. 12, *Degas Manet Morisot*, tr. David Paul (New York: Pantheon, 1960), 7.

5. Degas, *Je veux regarder*, 90.

6. Joris-Karl Huysmans, *Écrits sur l'art: L'Art moderne; Certains; Trois primitifs* (Paris: Flammarion, 2008), 245.

7. Degas, letter to Évariste de Valernes, October 26, 1890, quoted in Degas, *Je veux regarder*, 108.

8. Jean Sutherland Boggs et al., *Degas* (New York: Metropolitan Museum of Art, 1988), 369.

9. February 13, 1874.

10. Maurice Merleau-Ponty, *Le Visible et l'Invisible* (Paris: Gallimard, 1964).

11. François Thiébault-Sisson, "Degas sculpteur raconté par lui-même, 1897," *Le Temps,* No. 2553, August 11, 1931. Largely reprinted in Barbour et al., *Degas Sculpteur* (Paris: Gallimard, 2010), 85–87.

12. Ibid.

13. Ibid.

14. Ibid.

15. Théophile Gautier, "Le rat," in *Peau de tigre* (Paris: Michel Lévy Frères, 1866).

16. Ibid.

17. Ibid.

18. Thiébault-Sisson, "Degas sculpteur."

19. Jules Claretie, quoted in Henri Loyrette, *Degas: "Je voulais être illustre et inconnu"* (Paris: Gallimard, 1988), 393.

20. Edgar Degas, "Carnet 14," in *Carnets*. Online at Gallica.BNF.fr.

21. Degas, *Je veux regarder*, 13.

22. Pierre-Auguste Renoir, *L'Amour avec mon pinceau* (Paris: Mille et une nuits, 2009), 49.

23. Paul Gauguin, "Qui connaît Degas?" in Degas, *Je veux regarder*, 12.

24. Edgar Degas, letter to Henri Rouart, undated, *Lettres*, 100.

25. Degas, *Je veux regarder*, 117, note 41.

26. Jacques-Émile Blanche, *Propos de peintre: De David à Degas* (Paris: Éditions Émile-Paul Frères, 1927), 287.

27. May 16, 1823.

28. Alice Michel, *Degas et son modèle* (Paris: L'Échoppe, 2012), 38.

29. Renoir, *L'Amour*, 49.

30. Ambroise Vollard, *Souvenirs d'un marchand de tableaux,* in Barbour et al., *Degas Sculpteur,* 20.

31. Quoted in Henri Loyrette, *Degas: "Je voudrais être illustre et inconnu"* (Paris: Gallimard, 1988).

32. Madeleine Zillhardt, quoted in Degas, *Je veux regarder,* 131.

33. Edgar Degas, letter to Henri Rouart, December 5, 1872, *Lettres*, 26.

34. Degas, *Lettres*, 70.

35. Michel, *Degas et son modèle,* 73.

36. Rainer Hagen and Rose-Marie Hagen, *Les Dessous des chefs-d'œuvre* (Taschen, 2016), 427.

37. Vincent van Gogh, letter to Émile Bernard, August 5, 1888, No. 655, in Leo Jansen, Hans Luitjen, and Nienke Bakker, *Vincent van Gogh, Ever Yours, The Essential Letters* (New Haven: Yale University Press, 2014), 563. Online at vangoghletters.org.

38. Blanche, *Propos de peintre*, 293.

39. Renoir, *L'Amour*, 51.

40. Ibid., 50.

41. Degas, *Je veux regarder*, 12.

42. Paul Lafont, *Degas*, quoted in Pingeot and Horvat, *Degas: Sculptures*, 16.

43. Degas, *Je veux regarder*, 133.

44. Daniel Halévy, *Degas parle* (Paris: Éditions de Fallois, 1995), 19.

45. Ibid., 227.

46. Valéry, *Degas Dance Drawing*, 101.

47. Halévy, *Degas parle*, 39.

48. Philippe Gutton, *Balthus et le jeunes filles* (Paris: EDK, 2014), 177.

49. Quoted in "Balthus et Jouve: Alice dans le miroir" (1933), online at Ex-libris.over-blog.com.

50. Marilyn Monroe, *Fragments: Poems, Intimate Notes, Letters* (New York: Farrar, Straus and Giroux, 2010), 81.

51. Ibid., 77.

52. Halévy , *Degas parle*, 192–193.

53. Julien Gracq, *La Presqu'île* (Paris: Corti, 1970), 230.

54. Monroe, *Fragments*, 35.

55. Valéry, *Degas Dance Drawing*, 102.

56. Gracq, *La Presqu'île*, 74.

57. Degas, *Lettres*, 21.

THREE (PP. 107–133)

1. René Huyghes, quoted in Anne Pingeot and Franck Horvat, *Degas: Sculptures* (Paris: Imprimerie nationale, 1991), 19.

2. Roland Barthes, *A Lover's Discourse: Fragments*, tr. Richard Howard (New York: Hill and Wang, 2010), 98.

3. Paul Valéry, *Degas Dance Drawing*, in *The Collected Works of Paul Valéry*, Bollingen Series 15, vol. 12, *Degas Manet Morisot*, tr. David Paul (New York: Pantheon, 1960), 19.

4. Joris-Karl Huysmans, *Écrits sur l'art: L'Art moderne; Certains; Trois primitifs* (Paris: Flammarion, 2008), 200.

5. Roland Barthes, *Camera Lucida: Reflections on Photography* (New York: Hill and Wang, 2010).

6. Annie Ernaux, interview with Raphaëlle Rérolle, *Le Monde*, February 3, 2011.

7. Patrick Modiano, *Dora Bruder*, tr. Joanna Kilmartin (Berkeley: University of California Press, 2014), 119.

8. Ibid.

9. Martine Kahane, "Enquête sur la *Petite Danseuse de quatorze ans* de Degas," *Revue du musée d'Orsay* 7 (Fall 1998), 50.

10. Edgar Degas, *Lettres* (Paris: Grasset, 2011), 75.

11. Ibid., 48.

12. Ibid., 141.

13. Pierre Michon, interview with Thierry Bayle, *Lire*, 1997.

14. Henri Loyrette, *Degas* (Paris: Fayard, 1990), 672–673.

15. Degas, *Lettres*, 29.

CONCLUSION (PP. 135–147)

1. Pierre Michon, interview with Thierry Bayle, *Lire*, 1997.

2. Émile Zola, *Éd. Manet* (La Rochelle: Rumeur des âges, 2011), 9.

3. Quoted by Henri Loyrette (title of one of his works).

4. Anne Pingeot and Franck Horvat, *Degas: Sculptures* (Paris: Imprimerie nationale, 1991), 188.

SELECTED BIBLIOGRAPHY

EXHIBITION CATALOGS

Bakker, Nienke, Guy Cogeval, Mireille Dottin-Orsini, and Daniel Grojnowski. *Splendeurs et misères: Images de la prostitution 1850–1910*. Paris: Flammarion 2015.

Barbour, Daphné, Catherine Chevillot, Richard Kendall, Anne Pingeot, Shelley Sturman, and Bruno Gaudichon. *Degas Sculpteur*. Paris: Gallimard, 2010.

Boggs, Jean Sutherland, Douglas Druick, Henri Loyrette, Michael Pantazzi, and Gary Tinterow. *Degas*. New York: Metropolitan Museum of Art; and Ottawa: National Gallery of Canada, 1988.

Clair, Jean, ed. *Crime & châtiment*. Paris: Gallimard, 2010.

Haudiquet, Annette, and Géraldine Lefebvre, eds. *De Delacroix à Marquet — Donation Senn-Foulds II — Dessins*. Le Havre: MuMa; and Paris: Somogy éditions d'Art, 2011.

Hauptman, Jodi, Carol Armstrong, Jonas Beyer, Kathryn Brown, Karl Buchberg, and Hollis Clayson. *Degas: A Strange New Beauty*. New York: Museum of Modern Art, 2016.

Kendall, Richard, Douglas Druick, and Arthur Beale. *Degas and the Little Dancer*. New Haven: Yale University Press, 1998.

REFERENCE WORKS AND RESEARCH PAPERS

Kahane, Martine. "Enquête sur la *Petite Danseuse de quatorze ans* de Degas." *Revue du musée d'Orsay* 7 (Fall 1998).

Loyrette, Henri. *Degas*. Paris: Fayard, 1990.

———. *Degas: "Je voudrais être illustre et inconnu."* Paris: Gallimard, 1988.

Musée d'Orsay. *Degas inédit*. Paris: La Documentation française, 1989. (See, in particular, contributions by Douglas Druick and Henri Loyrette.)

Parent, Marie-Josée. "*La Petite Danseuse de quatorze ans*: une analyse de la version subversive de l'œuvre." Master's thesis, University of Montreal, 2009.

Pingeot, Anne, and Franck Horvat. *Degas: Sculptures*. Paris: Imprimerie nationale, 1991.

WORKS, CORRESPONDENCE, AND SAYINGS OF EDGAR DEGAS

Degas, Edgar. *Carnets*. Online at Gallica: gallica.bnf.fr.

———. *Les Carnets d'Edgar Degas*. Edited and introduced by Pascal Bonafoux. Paris: Le Seuil-BNF, 2013.

———. *Lettres*. Edited by Marcel Guérin. Preface by Daniel Halévy. Paris: Grasset, 2011.

———. *Je veux regarder par le trou de la serrure*. Paris: Mille et une nuits, 2012.

WORKS DEVOTED IN WHOLE OR IN PART TO EDGAR DEGAS

Blanche, Jacques-Émile. *Propos de peintre—De David à Degas*. Paris: Éditions Émile-Paul Frères, 1927.

DeVonyar, Jill, and Richard Kendrick. *Degas and the Dance*. New York: Abrams, 2002.

Halévy, Daniel. *Degas parle*. Paris: Éditions de Fallois, 1995.

Hofmann, Werner. *Degas*. Paris: Hagan, 2007.

Huysmans, Joris-Karl. *Écrits sur l'art: L'Art moderne; Certains; Trois primitifs*. Paris: Flammarion, 2008.

Terrasse, Antoine. *Tout Degas*. 2 vols. Paris: Flammarion, 1982.

Valéry, Paul. *Degas Dance Drawing*. Reprinted in *The Collected Works of Paul Valéry*, Bollingen Series 15, vol. 12, *Degas Manet Morisot*. Translated by David Paul. New York: Pantheon Books, 1960.

MISCELLANEOUS WORKS

Chevalier, Louis. *Classes laborieuses et classes dangereuses*. Paris: Plon, 1988.

Corbin, Alain. *Le Temps, le Désir et l'Horreur: Essais sur le XIXe siècle*. Paris: Aubier, 1991.

Dottin-Orsini, Mireille. *Cette femme qu'ils disent fatale*. Paris: Grasset, 1993.

Guest, Ivor Forbes. *The Ballet of the Second Empire*. London: A. and C. Black, 1955.

Houbre, Gabrielle, et al. *Le Corps des jeunes filles de l'Antiquité à nos jours*. Paris: Éditions Perrin, 2001.

Maingueneau, Dominique. *Féminin fatal*. Paris: Descartes, 1999.

LITERARY WORKS

Modiano, Patrick. *Dora Bruder*. Translated by Joanna Kilmartin. Berkeley: University of California Press, 2014.

Zola, Émile. *The Complete Works of Émile Zola*. Delphi Classics, 2013. Online at www.delphiclassics.com.

———. *Éd. Manet: étude biographique et critique*. Paris: Hachette, 2013.

———. *Nana*. Translated by Douglas Parmée. Oxford: Oxford University Press, 1992.

ARTICLES

Coons, Lorraine. "Artiste ou coquette? Les petits rats de l'Opéra au XIXe siècle." *French Cultural Studies*, vol. 25.

Flouquet, Sophie. "Degas en volume." *Journal des Arts*, January 7, 2011.

Keyes, Norman. "Degas and the Art of the Dance." *USA Today Magazine*, March 2003.

DVD

La Petite Danseuse de Degas. Based on an original idea by Patrice Bart and Martine Kahane. Directed by Vincent Bataillon. Original music by Denis Levaillant. Choreography and staging by Patrice Bart, with the Ballet and Orchestra of the Paris National Opera. Copyright: Opéra national de Paris — Telmondis — Bel Air Media — 2010.

CREDITS

41 Edgar Degas, *Two Dancers in the Foyer,* c. 1901 (pastel) / Private Collection / Photo © Lefevre Fine Art Ltd., London / Bridgeman Images

51 Edgar Degas, *Giulia Bellelli* (study for the Bellelli family), 1858 (engraving) / Bridgeman Images

56 Edgar Degas, *L'écolière,* c. 1880 (statuette in plaster, RF4614) / Photo: Hervé Lewandowski / Musée d'Orsay, Paris, France / Photo © RMN-Grand Palais / Art Resource, NY

72 *Edgar Degas,* c. 1900 / Spaarnestad Photo / Bridgeman Images

80 Edgar Degas, *Three Studies of a Dancer in Fourth Position,* 1879–80 (charcoal and pastel with stumping and touches of brush and black wash on grayish-tan laid paper with blue fibers, laid down on gray wove paper) / The Art Institute of Chicago, IL, USA / Bequest of Adele R. Levy / Bridgeman Images

83 Gauthier, photograph of Edgar Degas, *Little Dancer,* c. 1917–1918 (RF2137) / Repro-photo: Franck Raux / Musée d'Orsay, Paris, France / Photo © RMN-Grand Palais / Art Resource, NY

CAMILLE LAURENS is an award-winning French novelist and essayist. She received the Prix Femina, one of France's most prestigious literary prizes, in 2000 for *Dans ces bras-là*, which was published in the United States as *In His Arms* in 2004. Her second novel to appear in English, *Who You Think I Am* (Other Press, 2017), is the basis for a forthcoming film starring Juliette Binoche. Laurens lives in Paris.

WILLARD WOOD is the winner of the 2002 Lewis Galantière Award for Literary Translation and a National Endowment for the Arts Fellowship in Translation. His recent translations include *Constellation* by Adrien Bosc and *The Goddess of Small Victories* by Yannick Grannec. He lives in Connecticut.